CYCLES OF TASTE

LONDON : HUMPHREY MILFORD

OXFORD UNIVERSITY PRESS

CYCLES OF TASTE

AN UNACKNOWLEDGED PROBLEM
IN ANCIENT ART AND CRITICISM

BY

FRANK P. CHAMBERS

CAMBRIDGE · MCMXXVIII
HARVARD UNIVERSITY PRESS

PRINTED AT THE HARVARD UNIVERSITY PRESS

CAMBRIDGE, MASS., U. S. A.

INTRODUCTION

THE arts of ancient Greece and Rome are as inexhaustible as a source of veneration, as of controversy. Every lover of art and student of aesthetics seems somehow to learn a lesson from them, and must needs hold and defend an opinion concerning them. Yet while so much is said and written about ancient arts and aesthetics, the ancient Classical authors are seldom, if ever, consulted for what *they* said and wrote of their own arts and aesthetics. Pausanias and the Plinys and their literary brethren are made often enough to supply archaeological *lacunae:* but there their value ends, for they are not considered to be worthy representatives of the artistic ideas of their age.

The present Essay is designed to meet the problem of ancient aesthetics as discoverable in ancient literature. It begins with the assumption that, not in the tastes and controversies of modern art-lovers and art-critics, can a working theory of ancient aesthetics be discovered, but in

ancient literature itself. It believes that Pausanias and the Plinys are to be consulted for their thoughts and feelings as much as for their archaeological information. Briefly it seeks to answer the question: What had Classical Antiquity to say of its own arts? It sets itself therefore to recall some of the passages in ancient Classical literature, which allude to or discuss the arts, and to deduce some estimate of Classical aesthetics.

And in this the Essay's methods must needs be limited. Its approach to the problem is entirely literary. It allows nothing to be asserted as true without the support of an authentic literary record. It incurs the risk of assuming the intractable form of a catalogue of quotations with connecting comments; but it may thereby the better achieve its object. It withholds deliberately the apparent evidence of surviving ancient monuments and works of art, except where these would seem to corroborate the literary evidence. The possible misconceptions of modern students of antiquity, who by a recourse to the monuments alone read, as it were, an ancient mentality in the language of modern habits of criticism, can be obviated perhaps by some such imposition. The policy of the Essay, from first to last,

is that only by allowing the ancients to speak for themselves can a true estimate of their thoughts and feelings be made.

And having faithfully fulfilled this programme, the Essay may deem itself justified in its treatment of an Unacknowledged Problem in Ancient Art and Criticism.

CONTENTS

CYCLES OF TASTE

Die Alten stellten die Existenz dar, wir gewöhnlich den Effekt, sie schilderten das Fürchterliche, wir schildern fürchterlich, sie das Angenehme, wir angenehm, u. s. w. Daher kommt alles Uebertriebene, alles Manierirte, alle falsche Grazie, alle Schwulst, denn wenn man den Effekt und auf den Effekt arbeitet, so glaubt man ihn nicht fühlbar genug machen zu können. . . .

Man spricht immer vom Studium der Alten; allein was will das anders sagen als; richte Dich auf die wirkliche Welt und suche sie auszusprechen; denn das thaten die Alten auch, da sie lebten. . . .

Alle in Rückschreiten und in der Auflösung begriffenen Epochen sind subjektiv, dagegen aber haben alle vor-schreitenden Epochen eine objektive Richtung. Unsere ganze jetzige Zeit ist eine rückschreitende, denn sie ist eine subjektive. . . .

Das Principium verborgen bleibe, aus dem und durch das er arbeite.

<div align="right">GOETHE</div>

I

FIRST DEVELOPMENTS OF ART
VALUATIONS IN GREECE

ÆSTHETIC self-consciousness was born late
into ancient Greek culture. The Greek
knew not that he was an artist, till his arts were
well past their prime. The Parthenon and Pro-
pylaea were already built, and had become the
accustomed sights of Athens, before it was dimly
borne upon the Athenians that they were Works
of Art.

Prior to the fourth century A.D. there is no evi-
dence that works of art were admired, except for
their costliness and magnitude. In sculpture and
painting the first quality demanded was life and
realism.

The *Iliad* purports to describe the siege of
Troy, but speaks no words of Trojan architec-
ture. Troy is famed only for "her brass and gold,
the common theme of every tongue." [1] The typi-
cal palace of the *Odyssey* beams with brass and

gold, electrum and ivory. The palace of the Phaeacian king shone like the sun or moon. Bronze were its walls, cyanus its cornice, golden its doors, silver its door-posts and lintels, golden its door-handles, its thrones adorned with richest woven fabric, its torches held aloft by golden statues of boys. In this apocalyptic environment lived the immortal princes of Phaeacia.[2] In the *Iliad* descriptions of armor are numerous, as befits an epic of war. But this armour too is golden, silver-studded, brazen-clasped, star-spangled.[3] In the famous Shield of Achilles, such enrichments reach the limit of magnificence. A complete mythic encyclopaedia is thereon inlaid in gold and silver and brass. The scenes represented are described as if they existed, and lived most really.

And when the shield was wrought, there was made a corselet brighter than the flame of fire, a massive helmet fitted to his brows, and thereon was set a crest of gold. . . .[4]

The reaction of these dazzling works on Achilles' mind was to fire him the more for battle, a reaction not truly aesthetic!

There is nothing in the Homeric Hymns but mentions of "the rich-decked porticoes of the gods." [5] When Apollo founds his Delphic shrine

the poet is concerned, not with its architectural possibilities, but with its oracles.[6] The *Hymn to Hephaestus* is grateful to the divine artist, whose virtues it rehearses, only in that he taught men to live peaceful and prosperous lives. But, as before, there is the following gold-and-glitter imagery, which describes Aphrodite in a robe of gold,

enriched with all manner of embroidery, out-shining the brightness of fire, shimmering like the moon over her tender breasts, — a marvel to see. She wore twisted brooches and shining ear-rings in the form of flowers; and round her soft throat were lovely necklaces. . . .[7]

— doubtless a good picture of an archaic female statue in all its pristine gaudiness.

Hesiod's *Shield of Heracles* is fraught with the same gold-and-glitter as its model, the Homeric Shield of Achilles. Enamel, ivory, electrum, cyanus and various sculptured monsters of unspeakable frightfulness compose its ornaments.[8] The lyric poets indulge their taste for golden bracelets, purple robes, silver goblets, trinkets of ivory.[9] Pindar has his golden palaces and halls built on golden pillars and shining porticoes. Pindar's very flowers are golden; the bay-wreaths

(5)

of the victors at the games are golden; in his Isles of the Blessed are golden trees.[10]

Such must have been the typical appreciation in the archaic age of Greek culture. The Periclean age might however have introduced something more sophisticated. But there is nothing to prove that the mighty works of architecture, sculpture and painting, which the Greeks then executed, were at all synchronous with revolutions in aesthetic ideas.

Herodotus, the fifth-century historian, was an exact contemporary of Pericles. He traveled the then known world, and must have been fully conversant with the culture of his time. He is said to have read his *History* publicly to the Athenians at the Panathenaic festival of 445 B.C. — that is, at the time when the Parthenon was actually in process of erection. But he never in that *History* attains to anything more refined than the following:

Below in the same precinct, is a second temple, in which is a sitting figure of Zeus, all of gold. Before the figure stands a large golden table, and the throne whereon it sits, and the base whereon the throne is placed, are likewise of gold. The Chaldaeans told me that all the gold together was eight hundred talents in weight. Outside the temple are two altars, one of

solid gold, on which it is only lawful to offer suck-
lings; the other is a common altar, but of great size,
on which the full-grown animals are sacrificed. It is
also on the great altar that the Chaldaeans burn the
frankincense, which is offered to the amount of a
thousand talents in weight every year at the festival
of the God. In the time of Cyrus there was likewise
in this temple the figure of a man, twelve cubits high,
entirely of solid gold. . . .¹¹

And that is a fair sample of Herodotus. Herod-
otus is more impressed by the size of the Pyra-
mids and the walls of Babylon than by any Work
of Art.

The Funeral Oration of Pericles in Thucydides'
History is often seized upon by modern critics as
an epitome of Greek artistic idealism at its height.
If anything, it is suffused with puritanism, the
moral resistance to Fine Art, which, as shall be
seen, played so large a rôle in Greece. The cul-
ture of Athens was a subject for apologies. Hence
there is almost an under-consciousness of the
justice of the Spartan reproach that the Athe-
nians were sapping their manhood by their intel-
lectual diversions. "We are lovers of beauty,"
Pericles is made to say, "but of beauty only in
her frugal forms (φιλοκαλοῦμεν μετ' εὐτελείας), and
we cultivate the mind without the loss of man-

liness." [12] Furthermore there is no particular reason for interpreting these words as a reference to artistic beauty. It is more probable that this "beauty in her frugal forms" was the beauty of character, like the beauty which was later to obsess Plato. It is also impossible that the words κατασκευαῖς εὐπρεπέσιν, which translators generally render with difficulty as "appropriate structures" or "elegant homes," should be a definite allusion to contemporary architecture.[13] The significance of the word "monuments" (σημεῖα), which, Pericles is made to say, "will make us the wonder of this and of succeeding ages," must be judged from the remainder of Thucydides' *History*.[14] For as often as there is an occasion to praise Athens and her works, there is never a mention of her artistic achievements. Her empire, her victories and her freedom are her monuments. Once the Acropolis is described, but without a hint of architecture,[15] Pericles, when computing the sinews of war, adds that the gold plates of the Athena Parthenos might be used as a last resource. He assumes quite blandly that they could be restored afterwards, and he shows no solicitude for their immortal sculptor, whose very name he deigns not to mention.[16] The *History*

takes note of cities for the strength of their gar-
risons and of their defences, and for the wealth
they contain. Such cities are razed to the ground,
but there is never so much as a word of regret,
except for the loss of brave souls and material
property. The burning of a temple or the mutila-
tion of a statue only call forth diatribes on sacri-
lege. Thucydides had many an opportunity for
some aesthetic parenthesis. The continuity of his
narrative is interrupted to tell a myth, to observe
some rite or ancient custom, or to digress upon
the horrors of revolution and plague. But he
stops short of Fine Art.

The dramatists have but little occasion to men-
tion the arts. Examples of the typical gold-and-
glitter are, however, to be found in such works as
the *Persians* of Aeschylus, which harps constantly
upon the treasures and golden palaces of Persia,
and which no doubt was intended to flatter the
cupidity and patriotism of the Greek audiences.
Sophocles speaks of nothing but the dread holi-
ness of images and sanctuaries. Euripides does
once make a chorus walk round a temple and
name the scenes represented in the sculptures,
but he is not over-generous with his aesthetic in-
formation.[17] He represents Polyxena, sacrificed

at the tomb of Achilles, as rending her garments and "baring her bosom and breasts, as a statue, most fair" [18] — an allusion perhaps to the half-draped female statues then coming into vogue. He uses architectural terms as the "capital" of a column (ἐπίκρανον) and "well-columned" (εὐκίων) and so forth.[19] He uses similes such as following:

> Pity me — like a painter draw back,
> Scan me, pore on my woes.
> (οἴκτειρον ἡμᾶς, ὡς γραφεύς τ' ἀποσταθεὶς
> ἰδοῦ με κἀνάθρησον οἷ' ἔχω κακά.) [20]

But that is all. Otherwise the gold-and-glitter goes on.

In the same generation as Euripides, Socrates, the philosopher, finds in sculpture and painting themes for discourse. But his criticism is not more congenial to the modern art-lover than is the old gold-and-glitter. Yet tradition has it that Socrates was a trained sculptor and the wisest of the Athenians — qualifications excellently befitting an aesthetician. The theory implied in Socrates is the theory of Imitation, namely that the figures of the sculptor and painter are renderings of living originals, and that the excellence of such figures is to be judged by their truth to life. Statuary and painting are only representations at

second-hand of gods and men. This mimetic theory understands nothing in statuary which is now ennobled by the name of Sculpture. Statuary is beautiful only in the faithful portrayal of a beautiful model. The grandeur of the Athena Parthenos is the grandeur of Athena herself, and not the grandeur of the Art which bodies her forth. The kindly stateliness of a bust of Pericles is Pericles himself, whose likeness the carver has sought faithfully and naturalistically to reproduce.

Hence in Xenophon's *Memorabilia*, Socrates is made to argue quite typically that the Gods are greater artists than men, because they have made images which do really live, have senses, and serve a useful purpose.[21] He says to the painter, Parrhasios,

"Is not painting the representation (εἰκασία) of visible objects? At least you represent substances, imitating them by means of color, whether they be concave or convex, dark or light, hard or soft, rough or smooth, fresh or old." [22]

and to the sculptor, Cleito,

"I see and understand that you make figures of various kinds . . . but how do you put into your statues that which most wins the minds of the beholders, namely the life-like appearance?" [23]

These conversations close with a sense of conclusive satisfaction to all parties. The architecture of the *Memorabilia* makes no advance upon the "appropriate structures" of Thucydides. There is no word of the beauty of marble colonnades and porticoes.

Plato also saw no other end in art than imitation, and he founded his celebrated antipathy to works of art on the score of their being copies, and therefore, according to his philosophy, three times removed from reality. On more than one occasion he goes so far as to use the simile of the mirror in referring to poetry, sculpture and painting.[24] Aristotle wrote a treatise on imitation, the *Poetics*, which will always remain the classic exposition of the theory — although, it must be allowed, Aristotle's Imitation was of a very comprehending and expansive nature. His chief topic is tragedy, but he draws his instances from all the arts. He says:

The poet, being an imitator, just like the painter or any other maker of likenesses, must of necessity always represent things in one of three ways, either as they were or are, or as they are said or thought to be or to have been, or as they ought to be.[25]

Even music is for him a type of imitation:

Anger and mildness, courage and modesty, and
their contraries, as well as other dispositions of the
mind, are most naturally imitated by music and
poetry; which is proved by experience, for when we
hear these our very soul is altered; and he who is
affected either in joy or grief by the imitation of any
objects is in nearly the same situation as if he was
affected by the objects themselves; thus if any person
is pleased with seeing a statue of any one on no other
account but its beauty, it is evident that the sight of
the original from whence it was taken would also be
pleasing. . . .[26]

It is strange with what persistence the mimetic
idea of art survived in later times, even when
more refined types of artistic appreciation were
firmly established. Stories of statues coming to
life, and not merely appearing to live, are com-
mon. The myth of Pygmalion and Galatea is
first told by Ovid, but may well be a type of story
with an earlier popularity. So also would in-
sulted statues wreak vengeance upon their ene-
mies. Pausanias tells one such story, and adds
that the guilty statue was then solemnly indicted
for murder and thrown into the sea.[27] The myths
associated with the name of Hephaestus, the di-
vine craftsman, prove the insistence upon the
livingness of sculpture; for instance, his being
attended by certain golden creatures of his own

manufacture, having all the qualities of consciousness. The mythical sculptor and aviator, Daedalus, carved statues of such life-like properties that they had to be tied up to prevent their running away. Pliny's *Natural History* contains many anecdotes, most probably gathered from Greek sources, illustrative of this self-same demand for absolute realism. For instance, he tells of the oft-quoted competition between the fifth-century painters, Parrhasios and Zeuxis. Parrhasios painted grapes which the birds came to peck; but the other painted a curtain which seemed to cover a picture beneath, and this deceived all men. Accordingly Zeuxis, because he had deceived men, was awarded the prize, whereas Parrhasios had deceived only birds.[28]

If literary records are to be trusted, it is evident that the archaic and the fifth-century Greek possessed no consciousness of Fine Art in the modern sense. Even subsequent to that time, this Greek ignorance continued in a manner, which has perplexed and disappointed modern students of antiquity. The truth is that Greek art in its earliest and in its finest epoch was completely bound up with the life and religion of the people. Greek statues and pictures represented

Gods, heroes and men. Buildings supplied practical needs and perhaps embodied chosen traditional symbols. To these things the Greek dedicated his most precious possessions, his riches and his gold-and-glitter. But beyond the simplicity of such immediate ends, early Greek art had no self-conscious exalted ideals *per se*. A Greek artist, a contemporary of Pheidias, is once said to have thus expressed his praises of Attica, his home:

I behold the Acropolis, there is the symbol of the great trident in the Erechtheion; I see Eleusis, I am initiated into the sacred mysteries; I see Leocorion and the Theseion. To describe all is beyond my power, for Attica is the chosen residence of the Gods, and the possession of heroes its progenitors.[29]

It is perfectly in keeping with early Greek sentiment that he should herein make no mention of the architectural beauties, which his survey would necessarily include. Attica to him was worthy for its myths and not for the glory of its artistic handiworks. "All the statues and everything else equally on the Acropolis at Athens are votive offerings," said Pausanias in much the same spirit some centuries after.[30] The highest panegyric accorded to Pheidias by his contempo-

raries, was, not that he had created Art, but that he had enriched the received religion of the State. All his labors for the Athenians were set at nought, once he had been convicted for impiety, and all his genius as an Artist did not protect him from an obscure and shameful death.

Here then, in remoter antiquity, was an unfamiliar type of mind at work, a type which had its more recent counterpart in the Middle Ages, a type which no modern man can properly understand and appreciate in its depths. The least he can do is to acknowledge its existence, and acknowledge also the long and curious history of aesthetics, from these archaic beginnings to the high complexity of which his own times are the witnesses.

II

THE MORAL RESISTANCE TO
FINE ART IN GREECE

PREJUDICES overcome by modern art are generally prejudices of academic manners. Prejudices overcome by an archaic art are generally prejudices of custom and morality. A people in the first centuries of its history is disposed by a necessary principle to ignore or to suspect any occupation but what concerns its immediate livelihood. Furthermore the very quality, which appears to make art attractive in archaic times, the gold-and-glitter, would offend the age-old philosophic horror of the riches and of the covetousness of the world, and the early moralists would condemn unconditionally the very material of art, while that art was young, powerless and unjustifiable.

The Moral Resistance to Fine Art, as it shall hereafter be called in these pages, was established most invincibly in the state of Sparta. Here a

military caste ,rew up, supported economically
by a slave p ulation, and despising every pro-
fession but it of arms. Learning and the arts
were proscr ed. The poets were only admitted
for their t hings. Lycurgus, the Spartan law-
giver, is a to have edited Homer for his politi-
cal knov ge and his moral sentences.[1] When
Leonida as asked what he thought of the poetry
of Tyr s, he replied: "I think it is well calcu-
lated xcite the courage of our youth: for the
enthu m which it inspires makes them fear no
dang n battle."[2] In Sparta's later and declin-
ing rs, when Agis was reviving the ancestral
disc ne, he attacked among other luxuries that
of i orted music, "whose pompous superfluity,"
he clared, "would disturb the manners and
li of the people and destroy the harmony of
t state."[3] Architecturally, the squalor of
rta was proverbial. But the Spartan was well
itent to have it so, and deemed that, among
her advantages, the visits of foreigners would
e discouraged thereby. The temples and houses
vere of the meanest. Except for some tomb-
reliefs and images, sculpture was non-existent.
Public assemblies were held in the open, as build-
ings were supposed to distract the attention. Ceil-

ings of houses were, by law, wrought with no tool but the axe, to prevent unnecessary splendor.[4] The first respectable buildings of any kind in Sparta were Roman.

To a less extent the moral resistance prevailed in Athens. Solon, the lawgiver, was famous for his frugal laws. He persistently denied to Croesus, the king of fabulous wealth, the privilege of being the happiest man on earth. In his time, Thespis the poet began to change the form of tragedy. On being asked his opinion, Solon replied that Thespis should be ashamed to tell so many lies in public. "If we encourage such jesting as this," he added, "we shall soon have jesting in our contracts and agreements." [5] Another version of this story records that Solon categorically forbade the performances of Thespis' tragedies.[6] Even during the Athenian supremacy, the arts were held in suspicion. The apology of Thucydides has been cited already. It is entertaining to remember how universally that apology has been distorted to fit the myth that the early Greeks were an "artistic" people, and Thucydides himself an "artist" of no mean order. Pericles was continually reproached for spending the money of the Delian League on the

adornments of Athens, and his reputation in this respect was contrasted with that of Aristeides, "who in the whole course of his administration had no other object than virtue." [7] The Athenian philosophers busied themselves with exhortations to moral improvement, and only permitted the existence of the arts as object-lessons. The mimetic aspect of the aesthetics of Socrates has been mentioned. His aesthetic was also very largely moral. He defined the Beautiful always as the Useful. [8]

The prince of moralists was Plato. To him the only justification of a work of art, if it be not hounded out of the state altogether, was that it should teach. Hence he would expurgate all poetry, and serve up only the moral plums for the educational diet of his chosen guardians of the state.

We shall request Homer and the other poets not to be indignant if we erase these things; not that they are not poetical, and pleasant to many to be heard; but the more poetical they are the less ought they to be heard by children, and by men who ought to be free, and more afraid of slavery than of death. [9]

Painting, carving, architecture and "workmanship of all kinds" are also concerned with these things. Whence:

Not to the poets alone are we then to give injunctions and oblige them to work into their poems the image of the worthy manners or not at all to compose with us. We are to enjoin all other workmen likewise; and forbid the ill, undisciplined, illiberal, ungraceful manner and allow them to exhibit it neither in the representations of animals, in buildings, nor in any other workmanship; and he who is not able to do this, must not be suffered to work with us, lest our guardians, being educated in the midst of evil representations, as in an evil pasture, by every day plucking and eating much of different things, little by little, contract imperceptibly a great mass of evil in their souls. . . .[10]

Apart from its moral end, art has no right to exist, for art is fundamentally imitation, and out of touch with reality:

Painting, and in short all imitation . . . converses with that part in us which is far from wisdom, to no sound and genuine purpose. . . . Imitation then, being depraved in itself and joining with that which is depraved, generates depraved things. . . .[11]

And as he who in a city makes the wicked powerful, betrays the city, and destroys the best men, in the same manner we shall say that the imitative poet establishes a bad republic in the soul of each individual, gratifying the foolish part of it which neither discerns what is great, nor what is little, but deems the same thing sometimes great and sometimes little,

forming little images in its own imagination, altogether remote from the truth.[12]

Plato goes so far as to differentiate Art and Beauty.

The lovers of common stories and spectacles delight in fine sciences, colors, figures and everything compounded of these; but the nature of beauty itself their intellect is unable to discern and admire.[13]

Aristotle was accustomed to more humane notions; but the old morality does not altogether forsake him, for he always believed that the arts must subserve the end of the good. In drama, for instance, he says the drawing of the characters demands four points: "but the first and foremost is that they shall be good." [14] Likewise he says in another place: "If the men Zeuxis depicted be impossible, the answer is that it is better that they should be so: for the artist ought to improve upon his model." [15] He believed good portrait-painters to be those who, without losing the likeness yet made a sitter handsomer than he was [16]; — this was not the flattery practised in the days of fashionable portrait-painting such as Lucian satirized five centuries later.

All those who hear any imitations sympathize therewith and this when they are conveyed even

without rhythm or verse. Moreover as usic is one
of those things which are pleasant, and virtue it-
self consists in rightly enjoying, loving a hating, it
is evident that we ought not to learn o ccustom
ourselves to anything so much as to judg ght and
rejoice in honourable manners and noble ac 1s.[17]

So also the other philosophers of antiq :y ex-
hibited varying degrees of severity or tol tion.
Pythagoras was fabled to have descende into
Hades, where he saw the souls of Home and
Hesiod horribly tortured for the poems ey
wickedly wrote of the Gods.[18] Heraclitus us to
say that Homer deserved to be expelled d
beaten.[19] Xenophanes was at much pains to -
fute the immoralities in Homer and Hesioc
Diogenes the Cynic stalked the Hellenic wor
insulting every object of beauty and refinement.
In the very last decades of antiquity Apolloniu:
of Tyana was still championing the ancient moral
resistance. He is described by his biographer as
insensible to the splendors of Babylon during
his sojourn there. He advised the Smyrneans to
foster manhood rather than architecture, "for it
is more pleasing for a city to be crowned with men
than with porticos and pictures and with gold in
excess." To the Ephesians he writes: "It is no

use your decorating your city with statues and elaborate pictures and promenades and theatres, unless there is in you good sense and law." [22]

The modern mind has abstracted the function of Fine Art and purged it of all moral content. Hence a work may be "artistic" apart from what it portrays, like a filthy smoke-laden atmosphere by Whistler or a prostitute by Monet. But this modern ideal of Fine Art is an innovation, which a remoter age would never have understood, much less created for itself. The conception of Art as unique, inasmuch as it is the purer for being useless, had no analogy in the earlier periods of antiquity of which the present chapter treats. The exalted conception of Art as the externalisation of Beauty, which the modern mind takes for granted and never questions, did not find a consistent exponent until Plotinus. Beauty was moral and Art was moral; and Beauty associated with Art only under the auspices of a moral sanction. The Muses presided over the sciences and represented the whole conspectus of ancient culture. Architecture, sculpture and painting belonged to no Muse, but were protected possibly by such deities as Athena or Hephaestus, who turned these arts to profitable and honorable

(24)

purposes in life. It was wisdom which was made the aim of Muses of poetry. The Song of the Sirens promised to make men wiser! [23] And this is obviously the gist of the earliest literary criticism in antiquity, if it be worthy of the name, such as appears in Aristophanes' *Frogs:*

For what ought we to admire a poet? — For ready wit and wise counsel, and because he makes the people in the cities better men.[24]

If morality is an obstruction to the free creative impulses of Fine Art, — as modern aesthetics believes, — under such obstruction did Fine Art in Greece begin her course; nor was she freed even when she ran most strongly. That she did win her liberty in the end, only to find her true genius senile and decayed, and to pass away her final phases in melancholy reminiscences of a past that was more glorious though unfree, is a curious phenomenon in the story of the human mind, and one not without its lessons for all time.

III

FURTHER DEVELOPMENTS OF
ART VALUATIONS IN GREECE

THE moral resistance demonstrates *ipso facto* the existence of certain tastes, faintly realized perhaps, but of sufficient potentiality to be considered dangerous. Hence Plato exposes indirectly deliberately suppressed feelings. The art of oratory indeed was very fully developed in his day, as he himself shows in his attacks upon it.[1] And his mind is fully exercised by the problem of the inspired unwisdom of the poets.[2] But probably the earliest written record of the aesthetic appreciation of non-literary art is found in Aristophanes, who thus recommends the proper behavior of guests at a banquet:

> Extend your knees and let yourself
> With practised ease subside along the cushions;
> Then praise some piece of plate, inspect the ceiling,
> Admire the woven hangings of the hall.[3]

Then come in the last of Plato's works, the *Laws*,

certain significant remarks respecting architecture; and Plato seems almost to abandon his lifelong struggle, and to provide his second ideal city with those ornaments the first city ignored. He details the disposition of the site of the city and describes such features as its fountains, ornamented with plantations and buildings: . . .

and the building of these and the like works will be useful and ornamental; they will be a pleasing amusement also. (ταῦτα μὲν οὖν καὶ τὰ τοιαῦτα πάντα κόσμος τε καὶ ὠφέλεια τοῖς τόποις γίγνοιτ' ἂν μετὰ παιδιᾶς οὐδαμῇ ἀχαρίτου).[4]

In the *Critias*, Plato is almost loquacious. Like the *Laws*, the *Critias* was composed in Plato's declining years. It was left a mere fragment, but it is unique among Plato's works. Even the traditional horror of riches is temporarily suspended, and there comes a regular old-style gold-and-glitter description of a temple, with its coverings of silver, pinnacles of gold, and inlays of ivory and orichalcum. But there also comes the description of the imaginary palace of Atlas:

It was ornamented in successive generations . . . (ἕτερος δὲ παρ' ἑτέρου δεχόμενος κεκοσμημένα κοσμῶν), every king surpassing the one who came before him to the utmost of his power, until they made the building a marvel to behold for size and for beauty

(εἰς ἔκπληξιν μεγέθεσιν καλλεσίν τε ἔργων ἰδεῖν . . .
ἀπηργάσαντο). . . .

Some of their buildings were simple, but in others
they put together different stones, varying the pat-
tern to please the eye, and to be an innate source
of delight (καὶ τῶν οἰκοδομημάτων τὰ μὲν ἁπλᾶ, τὰ δὲ
μιγνύντες τοὺς λίθους ποικίλα ὕφαινον παιδιᾶς χάριν, ἡδονὴν
αὐτοῖς ξύμφυτον ἀπονέμοντες).[5]

Yet, all things considered, Plato is disappoint-
ingly jejune. His long disquisitions on beauty in
the *Gorgias, Philebus, Phaedrus, Symposium* and
the *Republic* evidently mean moral beauty and
bear no allusion to aesthetic beauty.[6] The quo-
tations given above only show that Plato could
have said more. Aristotle makes some improve-
ment on his master, but not as much as his ency-
clopaedic learning and his technical knowledge of
the arts would lead one to expect.[7] He definitely
permits art to cause pleasure, without any mis-
givings of conscience. Once indeed he says he
could not understand that music should be cen-
sured as mean and low, and he encourages
it especially for the honorable employment of
leisure.[8] The whole problem of tragic pleasure,
whose snares he foresees and which is still to-day
a favorite subject in literary discussions, is sig-
nificant of his attitude to the arts.[9] He even ad-

mits that the poet may sometimes allowably describe the impossible so long as the end of poetry be served, — a truly revolutionary admission, — which it is hard to realise any previous author making.[10] He refers, as in his similes, to painting and statuary, as Plato before him did; but also he respectfully names the individual artists themselves on many occasions, which Plato seldom did. There are passages here and there testifying to his interest in artistic matters. For instance:

. . . Just as in painting where the most beautif colors laid on without order will not give the s pleasure as a simple black-and-white sketch. (τις ἐναλείψειε τοῖς καλλίστοις φαρμάκοις χύδην, οὐκ ἂν ὁμοίως εὐφράνειεν καὶ λευκογραφήσας εἰκόνα).[11]

Oratory is like scene-painting. . . . The bigger the audience the more distant the point of view. . . in which case high finish of detail is superfluous and better omitted.[12]

Evidently Aristotle is a turning point in aesthetics — most developed in respect of the literary arts, but recognising to a lesser degree the non-literary arts of architecture, sculpture and painting. And yet again it must be confessed that his aesthetic admissions are hardly adequate in one whose pupil, Alexander, was to be a mon-

arch, an art-patron and one of the most ambitious builders of antiquity.

The age of Aristotle is less notable for crystallized aesthetic opinions than for the earliest appearance of the type of mind, which could make those opinions possible — namely, the dilettante. By the dilettante, the art-expert and connoisseur, the idea of Fine Art is first discovered apart from its traditional admixture with religion and morals. In short, the dilettante is a distilling influence. He is perhaps to be expected in an age which saw the beginnings of intellectual specialisation generally.

The earliest reference to dilettantism in Greece comes possibly in a fragment from a lost comedy of Menander.

. . . That he is a great dilettante and forever nurtured on sensuous music (. . . φιλόμουσον εἶν' αὐτὸν πάνυ ἀκούσματ' εἰς τρυφήν τε παιδεύεσθ' ἀεί).[13]

Then there is the well-known story of the cobbler, who for an indiscreet criticism of a work of art was advised to stick to his last. This story is told in connection with Apelles, the great painter and contemporary of Alexander the Great. There are also numbers of stories where Alexander the

Great himself was respectfully corrected for his misappreciation of works of art. Aristotle also seems at times to have some recognition of the art-expert. For instance he once says that music is a matter of skill and judgment and that only they who have practical knowledge can understand a performance rightly; and, he adds, "the same is true of painting." [14] Again he says:

Children are to be instructed in painting . . . not only to prevent their being mistaken in purchasing pictures, or in the buying and selling of vases, but rather as it makes them judges of the beauties of the human form; [15]

with the conceivable deduction that some picture dealing may have obtained in Aristotle's time. A supposititious work of Aristotle's seems to recognise the idea of "styles" of workmanship — and to foreshadow therein one of the ideas later to become so dear to the dilettante. Hence there is a reference to a statue by Daedalus, "wrought after the ancient manner," (εἰργασμένους τὸν ἀρχαῖον τρόπον), and to buildings in Sardinia, of the archaic Greek style (εἰς τὸν Ἑλληνικὸν τρόπον . . . τὸν ἀρχαῖον).[16] Theophrastus, the pupil and successor of Aristotle, in his work, the *Characters*, depicts the "plausible man" as a kind of connois-

seur indulging his tastes in monkeys, Sicilian doves, deer-horn dice, Thurian vases, walking-sticks "of correct Laconian curve," and curtains with Persians embroidered on them.[17] Theophrastus' "boastful man" in the same work is represented as discussing art and contending that Asiatic artists were incomparably superior to European.[18] Evidently dilettantism appeared in Greece in the fourth century B.C.

Alexander the Great, in the course of his marches, must have taken a true scholar's interest in the sights he saw, though policy must have actuated much of his curiosity. He undertook the perilous march to the Oasis of Ammon to ascertain his pedigree, but he never visited Thebes in Egypt, a safer and more interesting adventure. He was constantly celebrating sacrifices, holding games and festivals and propitiating local deities. But he would send home specimens of animals to his tutor, Aristotle, for the writing of the *Natural History;* and his promoting voyages of discovery of genuine scientific and geographical interest must have been a sign of inclinations, which would equally react upon his artistic tastes. The historian, Arrian, often refers to Alexander as "being seized with a desire to visit" something or

some place (ἐπὶ τούτοις δὲ πόθος λαμβάνει αὐτὸν ἐλθεῖν). Alexander paid extraordinary respects to Troy, where he decorated the tomb of Achilles with garlands.[19] Strabo says that Alexander found Troy a little village, containing a small and plain temple of Athena. After the victory of Granicus, he decorated the temple with offerings, gave the village the title of city, and ordered new buildings to be erected. Afterwards, when he had destroyed the Persian Empire, he sent a letter to the Trojans, expressed in kind terms, promising them to make their city great, to build them a temple of surpassing magnificence and to institute sacred games.[20] Alexander also visited the tomb of Sardanapalus at Anchialus and the tomb of Cyrus at Pesargadae. He proposed to restore the Hanging Gardens of Babylon, and ten thousand men were engaged for two months clearing away the débris alone; but his premature death put an end to further operations.[21] Alexander was always disposed to adopt with magnanimous catholicity useful ideas for incorporation in his great imperial schemes. The conception of the town-plan was adopted by him, probably from the vast dispositions of the temples of Egypt and the palaces of Persia; and the mentality of the

age was ready to welcome it in the embellishment of the new Hellenistic cities.

If Alexander conquered for curiosity, traveling for curiosity must have been a common practice in Hellenistic times. In the earliest times, philosophers, like Solon, Pythagoras and Plato, had sometimes traveled. But theirs was hardly aesthetic or antiquarian curiosity. Herodotus was the first of sight-seers, though, as has been observed, not possessed of a very sophisticated appreciation. Yet in the days to come his example was followed, and three centuries after him Polybius, the historian, was writing: "It is a peculiarity of these days that every sea and land has been thrown open to travelers." [22] And he noted that the great palace of Ecbatana — of which however he himself gives a very archaic account — was an object of unnecessary exaggeration among writers — a remark which denotes the prevalence of architectural travel. [23]

About this time writers on art subjects must have been numerous. There was already in existence a literature on architecture; but this appears to have been technical. [24] In the fourth century B.C., the Sophists may have written or lectured on art, and many, who by their profession had

become wealthy, were munificent patrons.[25] Men of leisure and eminence devoted superfluous hours to connoisseurship and literature. Such an one was Duris of Samos, who flourished in the fourth century. He was a pupil of Theophrastus, the philosopher, whose *Characters* has been cited. In his youth Duris had been an Olympian victor. He had a turbulent career and finally made himself tyrant of Syracuse. He wrote Lives of the Painters, Lives of the Sculptors, a book on athletics and a History of Greece. His interests in these works were probably picturesque and dramatic anecdote, and, like many of his literary brethren, he was more concerned with incidents in the lives of his personalities than with their achievements.[26] A similar type was Attalus III, king of Pergamon, in the second century. He was an assiduous collector of works of art, and is said to have purchased bodily the whole island of Aegina for the sake of its artistic relics. In later years he abandoned public business and devoted himself to the composition of treatises on physic, sculpture and gardening. He died leaving his empire to the Romans.

Hence in the Hellenistic Age collectomania was already *de rigueur* wherever respectability and

taste claimed to thrive. Polycrates of Samos is said to have collected "everything that was worth speaking of, everywhere, to gratify his luxury." He also sent for artists, promising enormous wages.[27] Dionysius of Syracuse used to raid the coasts of Greece and carry off the statues in the temples.[28] In Dionysius' time, Sicily was resplendent with great cities with their wealthy inhabitants, posing as miniature Pericles and surrounded by their libraries, sets of plate, antiques and Old Masters. Antiochus, the Seleucid monarch, was often found in the workshops of the silversmiths and goldsmiths, conversing with them on the subject of their arts and no doubt patronising them regally.[29] Aratus of Sicyon had a passion for pictures and collected particularly those by Pamphilius and Melanthus. He was on friendly terms with Ptolemy III, king of Egypt, to whom he presented pictures. When Aratus restored Sicyon to liberty he was almost prevailed upon to preserve the portraits of the hated tyrants painted by Melanthus.[30] Apellicon, in the time of Athenio, tyrant of Athens, was a famous bibliophile and publisher. He used to steal "the autograph decrees of the ancients, and everything else that was ancient and precious." [31]

Cleopatra, queen of Egypt, had artistic tastes. She spent five minae a day on Rhosic earthenware.[32]

After the birth of Christ, in Graeco-Roman times, the fruits of this dilettantism, as it may still be called, were rich and plentiful. Strabo, the geographer, is eloquent, especially over the sights of Rome, then at the zenith of her Augustan period. He says little of Greece, which probably he never knew well. He writes for instance:

The ancients, occupied with greater and more necessary concerns, paid but little attention to the beautifying of Rome. But their successors, especially those of our own day, without neglecting these things, have at the same time embellished the city with numerous and splendid objects. Pompey, Divus Caesar and Augustus . . . have surpassed all others in their zeal and munificence in these decorations. The greater number may be seen in the Campus Martius, which in addition to Nature added artificial adornments (πρὸς τῇ φύσει προσλαβὼν καὶ τὸν ἐκ τῆς προνοίας κόσμον). . . . The structures which surround it, the turf covered with herbage all the year round, the summits of the hills beyond the Tiber, extending from its banks with panoramic effect (σκηνογραφικὴν ὄψιν), present a spectacle which the eye abandons with regret. Near to the plain is another surrounded with columns, sacred groves, three theatres, one amphitheatre, and superb temples in

close contiguity to each other: and so magnificent, that it would seem idle to describe the rest of the city after it. . . . If from hence you proceed to visit the ancient forum, which is equally filled with basilicas, porticos and temples, you will there behold the Capitol, the Palatine, with the noble works which adorn them, and the piazza of Livia, each successive place causing you speedily to forget what you have before seen. Such then is Rome.[33]

Strabo's remarks on the Pyramids and temples of Thebes in Egypt are meagre. Evidently Egyptian art was not to his taste. He speaks of a temple at Bubastis as having "a great number of columns, as at Memphis, in the barbaric style (βαρβαρικὴν ἔχων τὴν κατασκευήν), for except the magnitude and number of the columns, there is nothing pleasing nor easily described, but rather a display of labor wasted." But, as a true antiquarian, he notices the resemblance between Egyptian sculpture and the archaic Greek.[34] Then in one singular passage he develops an almost mystical theory of Fine Art and speaks of music as containing the elements of the divine, "on account of the pleasure it inspires and by the perfection of its art" (ἡδονή τε ἅμα καὶ καλλιτεχνία πρὸς τὸ θεῖον ἡμᾶς συνάπτει). He adds casually:

For it has justly been said that men resemble the

gods chiefly in doing good, but it may be said more properly, when they are happy. . . .[35]

— an aesthetic doctrine most romantically modern.

Plutarch, the historian, is generally silent except for cities which he would know personally. Of the Jupiter Capitolinus Temple at Rome, he writes:

Tarquin is said to have expended thirty thousand pounds' weight of silver upon the foundations alone; but the greatest wealth any private citizen is supposed to be now possessed of in Rome would not answer to the expense of the gilding of the present temple (Domitian's), which amounted to more than twelve thousand talents. The columns are of Pentelic marble, and the thickness was in excellent proportion to their length, when we saw them at Athens; but when they were cut and polished anew at Rome, they gained not so much in the polish, as they lost in proportion and beauty; for they are now injured by their appearing too slender for their height (οἱ δὲ κίονες ἐκ τοῦ Πεντελῆσιν ἐτμήθησαν λίθου, κάλλιστα τῷ πάχει πρὸς τὸ μῆκος ἔχοντες· εἴδομεν γὰρ αὐτοὺς Ἀθήνησιν. ἐν δὲ Ρώμῃ πληγέντες αὖθις καὶ ἀναξυσθέντες οὐ τοσοῦτον ἔσχον γλαφυρίας ὅσον ἀπώλεσαν συμμετρίας καὶ τοῦ καλοῦ, διάκενοι καὶ λαγαροὶ φανέντες).[36]

Of the Athens of Pericles, he writes:

That which was the chief delight of the Athenians, and the wonder of strangers, and which alone serves

for a proof that the boasted power and opulence of ancient Greece is not an idle tale, was the magnificence of the temples and public buildings. . . . Works were raised of an astounding magnitude, and inimitable beauty and perfection, every workman striving to surpass the magnificence of the design with the elegance of the execution; yet still the most wonderful circumstance was the expedition with which they were completed; . . . for ease and speed of execution seldom give a work any lasting importance, or exquisite beauty; while, on the other hand, the time which is expended in labor is recovered and repaid in the duration of the performance. Hence we have more reason to wonder that the structures raised by Pericles should be built in so short a time, and yet built for ages; for as each of them, as soon as finished, had the venerable air of antiquity, so, now they are old, they have the freshness of a modern building. A bloom is diffused over them, which preserves their aspect untarnished by time, as if they were animated with a spirit of perpetual vigor and unfading youth (οὕτως ἐπανθεῖ καινότης ἀεί τις ἄθικτον ὑπὸ τοῦ χρόνου διατηροῦσα τὴν ὄψιν, ὥσπερ ἀειθαλὲς πνεῦμα καὶ ψυχὴν ἀγήρω καταμεμιγμένην τῶν ἔργων ἐχόντων).[37]

Thucydides would never have written in this vein! Perhaps it is better that he did not.

A significant product of the Graeco-Roman age was the tourist's guide. It is even probable that many a famous temple had now become little better than a repository of works of art, with

Daedalus are somewhat odd to look at, but there is a wonderful inspiration about them" (Δαίδαλος δέ ὁπόσα εἰργάσατο, ἀτοπώτερα μέν ἐστιν ἔτι τὴν ὄψιν, ἐπιπρέπει δὲ ὅμως τι καὶ ἔνθεον τούτοις).[46] And also against contemporary critics and travelers, he writes:

The Greeks, it seems, are more apt to admire things out of their own country than things in it, since several of their notable historians have described in great detail the Pyramids of Egypt, but have not mentioned at all the Treasury of Minyas and the walls of Tiryns, though they are no less remarkable.[47]

And this is reminiscent of the habits of many a modern tourist.

Athenaeus, the Alexandrian scholar of the third century A.D. has some affinities with Pausanias, his older contemporary, but is evidently a more cultured man. His extant *Deipnosophists* is a laborious anthology of some six hundred authors and has reference, direct or indirect, to the pleasures of banqueting and to the conversations then fashionable at the banquets of the learned. Athenaeus is the complete connoisseur and bibliophile. A kind of elegant smugness, which characterises many a modern university don, is the

chief ornament of his good nature. His chapter
in the *Deipnosophists* on drinking-cups displays
all the refinements of his academic sensibility.
Of this "multitude of beautiful cups, made with
every sort of various art," (εἰς τὸ πλῆθος τῶν καλῶν
τούτων καὶ παντοδαπῶν κατὰ τὰς τέχνας ἐκπωμάτων),
he names over a hundred kinds, many again hav-
ing distinctive genera and subgenera, and he dis-
cusses their artistic merits, their various uses, the
etymology of their names, and so forth.[48] He
quotes liberally from works on art subjects and
indicates the verbose appreciations of his time.
Many of these hark back to the old gold-and-
glitter, with evident relish for the euphony of the
gold-and-glitter vocabulary.[49] The following are
titles of works on art subjects from which Athe-
naeus quotes:

> The Acropolis at Athens in fifteen books, by
> Heliodorus.
> The Temples of Alexander, by Jason.
> The Treasures in the Temple of Hera at Delphi.
> On Statues and Images, by Hegesander.
> On Sculptors, by Adaeus.
> On Handicraftsmen, by Nicochares.
> History of Things to be seen in Egypt.
> On the Pictures, by Clearchus.
> And books on Inscriptions, Voyages and Itiner-
> aries by various authors.

Athenaeus says he took a great fancy to some of the expressions in Clearchus' treatise on Pictures, and he is willing to lend the book to his friends, "for one may learn a good deal from it, and have a great many questions to ask about it." [50] It is evident that works of art were regular themes in the learned confabulations at which the like of Athenaeus were wont to assist.

Athenaeus' principal artistic and antiquarian authority is a certain Polemo, whom he calls an Academic philosopher, a geographer, and surnames Periegetes. Athenaeus also calls him Stelocopas for his industry in reading inscriptions. Polemo was evidently a man of eminence in scholastic circles, and a type of the Graeco-Roman savant. From other sources Polemo is known to have been granted the privilege of free travel by the Emperor Trajan, and to have pronounced the dedicatory oration at the temple of Jupiter Olympus at Athens — no mean honor.[51] Polemo's writings comprised letters, controversial pamphlets, histories and the following works:

On the Acropolis at Athens.
On the Painted Colonnade at Sicyon.
On Inscriptions.
On Painters.

On the Sacred Games at Carthage.
On the Offerings at Lacedaemon.
On Wonderful People and Things.

Polemo and Athenaeus conjure up a picture of
the mentality which flourished in the polite so-
ciety of the seventeenth and eighteenth centuries
in Europe, and represented by such dictators as
Burlington. It was erudite, self-satisfied and
gentlemanly. It had its perversions in the shape
of the pedants and purists. Judging by the exist-
ence of the word ψευδεπίγραφος, art forgeries may
then have been as rampant. The learned world
of to-day ignores or looks back upon the century
of Athenaeus with contempt, but there is an un-
mistakable parallel between them.

The history of Greek aesthetics now nears its
end. Its final act is to dishonor its early gods
completely, and to repudiate both the gold-and-
glitter and the mimetics of archaic times. Hence
the satirist, Lucian, who scatters artistic refer-
ences generously throughout his writings, achieves
his finest descriptive passage in the *Hall*, and his
tastes, and the tastes of his contemporaries, may
be fairly judged from extracts from that work:

It would scarcely be too much to say that through
the medium of the eyes, beauty is borne in upon the

mind, and suffers no thought to find utterance before it has received her impress. (σχεδὸν γὰρ εἰσρεῖ τι διὰ τῶν ὀφθαλμῶν ἐπὶ τὴν ψυχὴν καλόν, εἶτα πρὸς αὐτὸ κοσμήσασα ἐκπέυπει τοὺς λόγους). . . .

Gold is gold, an uncouth manifestation of solid wealth, calculated to excite envy in the beholder, and to procure congratulations for the possessor, but far from creditable to the artist. . . .

What admirable judgment has been shown, too, in the structure and decoration of the roof. Nothing wanting, yet nothing superfluous; the gilding is exactly what was required (κἂν τῷ εὐκόσμῳ τὸ ἀνεπίληπτον, καὶ τὸ τοῦ χρυσοῦ ἔς τὸ εὐπρεπὲς σύμμετρον). . . .

Observe, too, that the gold is not otiose, not merely an ornament among ornaments, put there to flatter the eye; it diffuses soft radiance from end to end of the building, and the walls are tinged with its warm glow. Striking upon the gilded beams, and mingling its brightness with theirs, the day-light glances down upon us with a clearness and richness not all its own. . . .

Then Lucian compares the frescoed walls, "with their exquisite coloring, so vivid, so highly finished, so true to nature," (καὶ τῶν χρωμάτων τὰ κάλλη, καὶ τὸ ἐναργὲς ἑκάστου, καὶ τὸ ἀκριβὲς, καὶ τὸ ἀληθὲς), to a flowery meadow, the merit of this particular meadow being that it fades not.[52]

In Philostratus' *Life of Apollonius of Tyana*, the archaic mimetic theory of art is cast aside for

a substitute, the theory of creative imagination, which Philostratus calls ἡ φαντασία. Philostratus alludes to the Olympian Zeus, the Athena Parthenos, the Cnidian Aphrodite, and to "other images equally lovely and full of charm" (ὧδε καλὰ καὶ μεστὰ ὥρας). He continues:

Imagination wrought these works, a wiser and a subtler artist than imitation. For imitation can only create what it has seen; but imagination can create what it has not seen; for it will conceive of its ideal with reference to reality; and imitation is often baffled by terror, but imagination is baffled by nothing; it marches undismayed to the goal which it has itself laid down.[53]

There are sentences in the *Life of Apollonius* with a curiously modern ring:

Every art is interested in decoration, for decoration is the very *raison d'être* of the arts (κόσμου γὰρ ἐπιμελήσεται τέχνη πᾶσα, καὶ αὐτὸ τὸ εἶναι τέχνας ὑπὲρ κόσμου ηὕρηται).[54]

He speaks of the art of Zeuxis, Polygnotus and Euphranor, "who delighted in light and shade, and infused life into their designs, as well as a sense of depth and relief" (οἳ τὸ εὔσκιον ἠσπάσαντο καὶ τὸ ἔμπνουν καὶ τὸ ἐσέχον τε καὶ ἐξέχον). "The character of the pictures," he adds, "was

also pleasing in itself" (ἡδὺ δὲ καὶ αὐτὸ τὸ ἦθος τῆς γραφῆς).[55]

Finally in Plotinus, the last of the greater Pagan philosophers, the doctrine of Fine Art as the expression of an absolute value, Beauty, is consistently developed. Hence Plotinus can speak of such abstract qualities as "rhythm and design" (καὶ ῥυθμοὺς καὶ σχήματα) in the things of sense, and as "the correspondence and reasoned scheme" (αἱ ἀναλογίαι καὶ οἱ λόγοι) of a work of art; and these are the media by which Beauty manifests herself. And this Beauty, which gives "comeliness to material forms and sweetness to sounds" (καὶ τὰ σώματα καλὰ . . . καὶ ταῖς φωναῖς ὡς καλαί), is the Universal Soul of Plotinus' philosophy, sustaining and determining the transient forms of the world.[56] Most art-lovers today are subscribers to some such philosophy as that which Plotinus preached; but they do not remember that Plotinus taught in an age of "decadence," and that his ideas were as transitory as his age.

With writers like Lucian, Philostratus and Plotinus the conception of the Beautiful in Fine Art is complete, so far as Greece is concerned. Antiquity in their days was in a state of passage.

The first great invasion of the Goths took place in Plotinus' own lifetime. Aesthetics, then, beginning with the archaic glamor of Homer's golden palaces, resisted blindly by the early moralists, first emerging into a definable self-consciousness at the hands of Aristotle and his Hellenistic successors, at last, in the decadent days of Paganism, arrived at a state very obviously modern. The ideas of design and form, of creative imagination and the mystical appreciation of beauty, such as are now the ordinary accepted bases of the conception of Fine Art, are all distinctly traceable in the writings of these latter-day prophets of antiquity. Aesthetics in the thousand odd years of ancient Greece was no stationary factor and no permanent "Greek Ideal," but an almost fateful movement riding upon the current of history.

But at this point the argument must be postponed to go back and describe the contribution to aesthetics made by Rome and by the Latin authors.

IV

THE MORAL RESISTANCE
IN ROME

EARLY Rome conceded few honors to Sparta in the austerity of her moral ideal. Agriculture, war, and civil politics busied the Roman mind to the exclusion of more refined and passive entertainments. When culture came, the Roman owed that culture to the Greek, but acknowledged his debt with reluctance. To primary prejudices was added a contempt of the manners and language of a conquered people.

The Roman first tasted Greek art during the second Punic War when Fabius Maximus captured and sacked Tarentum, the old Lacedaemonian colony at the foot of Italy. He treated the temples with due reverence, but carried off for his triumph a colossus of Heracles, the work of Lysippus.[1] Next, Marcellus captured and sacked Syracuse in Sicily, and appeared later in Rome for his triumph with a goodly haul of

Greek statuary, pictures, and plate. These events filled the Roman puritans with apprehension, and some sagaciously prophesied that the seeds had been sown which would bring the great City and Empire to ruin. Even Greek writers dated the decline of Rome from the aesthetic indiscretions of Marcellus. Polybius, commenting on the fall of Syracuse said: "A city is not adorned by what is brought from without but by the virtues of its own citizens." [2] Plutarch believed that the proceedings of Marcellus were invidious to Rome, because he had led not only men but the very Gods in triumph; and he had spoiled a people inured to agriculture and war, wholly unacquainted with luxury and sloth, by furnishing them with an occasion for idleness and vain discourse — "for they now began to spend a great part of the day in disputing about art and artists." [3]

In these days flourished Cato the Elder, a very incarnation of old Roman virtues. The Romans made him Censor of public morals. "The Romans did not think it proper that anyone should be left to follow his own inclinations without inspection and control by the state, either in marriage, in the procreation of children, in his table

or in the company he kept." Cato, as Censor, stopped all building operations with a heavy hand, and prevailed upon the Senate to annul the contracts already made for the repairing of temples and public buildings, for these were detrimental to the state. He prided himself upon the fact that he had no statue erected to him, saying he had much rather it should be asked why he had not a statue than why he had one. When, however, a statue was raised, the inscription was to this effect: "In honor of Cato, the Censor, who, when the Roman Commonwealth was degenerating into licentiousness, by good discipline and wise institutions, restored it." He argued that the law passed after the battle of Cannae, that no Roman woman should wear gold or embroidered clothes, should never be repealed. But he was hotly opposed in the Senate and many women rushed in and put on their ornaments in his very presence. On one occasion he peremptorily sold a piece of Babylonian tapestry which he had inherited, believing it to be a dangerous luxury. He was alarmed at the arrival of Athenian philosophers in Rome, and especially at their popularity among the Roman youth. He even forbade a son of his in Athens to study medicine.

He said Socrates was a prating, seditious fellow, and that as soon as the Romans should imbibe the Grecian literature, they would lose the empire of the world. Yet toward the end of his illustrious career, Cato is said to have set himself to study the Greek language, and once when in Athens for a short time he did express his admiration of the Athenians, for the virtues of their ancestors and the beauty of their city.[4]

In 146 B.C. the Romans crossed the Adriatic, and the rapid subjugation of Greece culminated only eleven years afterwards when Pergamon became a Roman province. But the first Roman generals in Greece showed Greece less consideration than Marcellus showed Syracuse. Mummius destroyed Corinth entirely. "The soldiers cared nothing for the works of art and consecrated statues," says Polybius; "I saw with my own eyes pictures thrown down on the ground and the soldiers playing dice upon them." [5] Sulla, besieging Athens, felled the trees in the Academy and the Lyceum for his war-engines. He robbed the treasuries at Epidaurus, Delphi and Olympia to replenish his chest. It was supposed by some that he was resolved on the sack of Athens because he was jealous of her ancient renown. He

laid the Piraeus in ashes.[6] Fimbria destroyed
Troy and slaughtered its inhabitants. Marius,
conqueror of Jugurtha, took a pride in his igno-
rance of Greek letters; "I did not greatly care to
become acquainted with them," he said, "since
they had not taught their teachers virtue." [7] And
when after his second triumph he dedicated a
temple and exhibited shows to the people in the
Grecian manner, he barely entered the theatre
and sat down, and then rose up and departed
immediately.[8]

Marius died in the year 86 B.C. Sallust, the
historian, was born the same year. He deplored
the growing demoralization of the Roman people
and blamed Sulla for first corrupting his sol-
diers in charming and voluptuous foreign lands.
"There it was," he wrote, "that an army of the
Roman people first learned to indulge in women
and drink, to admire statues, paintings and chased
vases, to steal them from private houses and
public places, to pillage shrines and to desecrate
everything, both sacred and profane." [9] Cor-
nelius Nepos, his contemporary, in the Preface
to his *Lives of Eminent Commanders* apologises
that he must record the musical talents of Epami-
nondas and similar incidentals, which in Roman

estimation would doubtless be thought trifling for the character of a great soldier.

Cicero affected puritanism in public; though in private he cultivated many a polite taste. He referred sneeringly to those who had for relaxation a pleasant suburban villa and farms, every one of which was beautiful and furnished with Corinthian and Delian ware.[10] He eulogised Pompey for not turning aside from duty for the luxury and delights of Greek cities. "As for the statues and pictures and other embellishments, which other men think worthy to carry off, Pompey did not think them worthy even of a visit from him."[11] Cicero said his ancestors gave the name "inert" to the Fine Arts (*inertes artes*) because they were good for nothing.[12] Even oratory and literature he classed with history, geography, statues, pictures, beautiful scenery, sport, villas, as the less serious matters of life.[13]

Cicero's greatest exposition of the moral resistance was the prosecution of Verres, ex-praetor of Sicily, who had there used his authority to rob the Sicilians of their art treasures. Faithful to the ancient maxims of the Republic, Cicero affected to speak of the Fine Arts with calculated disdain. He pretended not to be too well ac-

quainted with the very names of famous artists
of antiquity, as Polycleitus and Praxiteles, and
to pride himself upon his ignorance. He referred
to the Greeks by the contemptuous diminutive
"Graeculi." There was in the prosecution a tone
more calculated to render Verres ridiculous than
hateful for his rapacity. Cicero constantly
punned on the word Verres, which means "a
pig." His most serious charge against Verres
was not vandalism, but sacrilege, ingratitude
for hospitality, and disregard of the holiness of
temples which he had plundered. "Verres," de-
clared Cicero, "behaved himself in his province
for three years in such a manner that war was
supposed to have been declared by him, not
only against man, but also against the immor-
tal Gods." [14]

Varro, the great scholar of Cicero's age, seems
also to have been an orthodox believer in the an-
cient virtues. For all his learning, or his reputa-
tion for learning, to which ancient writers have
testified, — for he wrote nearly five hundred
books on subjects of every interest, poetry, satire,
literary criticism, science, history, education,
philosophy, law, grammar, antiquities and even
architecture,— he remained true to the tradi-

tions of the Republic. His only complete extant work, a book on farming, represents him as a puritan in art. He is constantly contrasting the thrift of the past with the luxury of his time.[15] Agriculture, he says, makes hardy folk; but the sedentary dwellers of the city must needs introduce the gymnasium, which they dignify with a host of Greek names.[16] He asks whether the severer villas of his ancestors were not in better taste than the luxurious mansions with their citrus wood, gold, mosaic, and pictures, then being built. "My villa shows no trace of Lysippus, though much of the hoer and shepherd." [17] He uses the word "rhinthon," a fop, in reference to the man of taste.[18] And Varro wrote this book at the end of a long and busy life, when it may be supposed his opinions were crystallised and confirmed.

The Emperor, Augustus, patron and builder as he was, instituted a purge of contemporary morals. He lived himself with studied simplicity and endeavored to revive the older days when the Roman was either a farmer or a soldier. He banished Ovid for the *Ars Amatoria* and caused all copies of the work to be removed from the public libraries. Horace, in conformity with the

reform of his Emperor, would dilate upon the invasion of luxuries, and describe his age as "teeming with sin" (*fecunda culpae*).

Go now, look with transport upon silver, and antique marble, and brazen statues, and the arts; admire gems and Tyrian dyes; to admire nothing is almost the only thing which can make a man happy and keep him happy.[19]

Livy wrote his great *History* in the reign of Augustus and probably published it soon after Augustus' death. Rome was then a city of surpassing architectural magnificence and already replete with choicest specimens of Greek sculpture and painting. But Livy's *History* reads like a dirge whose subject is the decay of Roman civilization by luxury and superstition. He is oblivious to Fine Art, and records without comment the building and destruction of cities, the consecration and violation of temples. He has a sarcastic paragraph on the growth of the drama in Rome and says: "From what modest beginnings has it reached its present pitch of extravagance, scarcely to be supported by opulent kingdoms." [20] And of course he must revile Marcellus at Syracuse, whose spoils dedicated at Roman temples, he says, detracted from the honor of the gods.[21]

He observes that Archimedes of Syracuse was skilled in the stars, but deserving of more admiration as a designer of engines of war.[22] Livy's particular delight is the victory of a simple iron-clad Roman soldier over an enemy arrogantly arrayed in gold and silver armor. Roman soldiers, he says, were taught that valor was the brightest ornament, and that gold trinkets should rather follow than precede victory.[23] He is, therefore, in his rights to exult over the gold and silver spoils of captured cities.[24] The single exception to this resistance to art is a fairly full account of the sight-seeing tour of Paulus Aemilius in Greece.[25]

But the disease of Fine Art had already eaten into the flesh of Rome. Half a century after Augustus' death Nero was disgracing himself in Roman eyes driving horses in the Circus, performing tragedy in the theatres. "Formerly," writes Tacitus of Nero's behavior, "even Pompey was censured for nothing more than that he built a permanent theatre," and Tacitus proceeds to discuss the degeneracy of morals caused by the foreign importations, rhetoric, poetry and the palaestra.[26]

The last fight of the moral resistance in Rome

was fought by the Stoics. Seneca, at one time
Nero's master and adviser, spent a long and re-
spected life devoted to moral teaching and ex-
ample. His perpetual theme is the vanity of
riches.

I see tables and pieces of wood, valued at the price
of a senator's estate, which are the more precious the
more knots the tree has been twisted into by disease.
I see crystal vessels, whose price is enhanced by their
fragility, for amongst the ignorant the risk of losing
things increases their value, instead of lowering it, as
it ought. I see murrhine cups, for luxury would be
too cheap if men did not drink to one another out of
hollow gems, the wine to be afterwards thrown up
again. I see ladies' silk dresses, if those deserve to be
called dresses which can neither cover their body,
nor their shame, when wearing which they can
scarcely, with a good conscience, swear that they
are not naked. . . .[27]

Seneca commends Scipio Africanus, not only be-
cause he was a leader of armies, but because of
his moderation in all things, especially in the
decoration of his house.

But today how many great pictures are there,
great columns supporting nothing, but placed for
ornament and ostentation of expense, and fountains
whose waters fall and flow by degrees to make the
noise more pleasant? [28]

In olden days thatch covered the homes of free-
men; but servitude now dwelleth under marble and
gold. . . . May we not live in a house without the help
of the stone-carver, and clothe ourselves without
commerce with the Chinese? [29]

The only excuse for the Fine Art, he claimed, is
peace of mind and virtue.[30]

Marcus Aurelius, the Stoic Emperor, culti-
vated in his younger days the arts of the orator,
and seems also to have had antiquarian inter-
ests.[31] His tutor then was Fronto. But in later
years he acknowledged having learned nothing
from Fronto but to note the envy and dissimula-
tion of tyrants.[32] Of his father, he wrote:

I am thankful to the Gods, that I was subjected to
a ruler and a father who was able to take away all
pride from me, and to bring me to the knowledge
that it is possible for a man to live in a palace with-
out wanting either guards or embroidered dresses,
or torches and statues and such like show . . . that I
did not waste my time on writers (of histories) or in
the resolution of syllogisms, or occupy myself about
the investigation of appearances in the heavens; for
all these things require the help of the gods and
fortune.[33]

The works of this austere Emperor are now pub-
lished in *de luxe* editions with decorative illus-

trations and tooled leather bindings, as the approved ornament of the drawing-room table!

The last of the greater Latin poets, Juvenal, bitterly satirizes the vice and luxury of his time. He says,

It is to their crimes that proprietors are indebted for their gardens, their palaces, their tables, their fine old plate and the goat standing in high relief in their cups.[34]

Which of our grandsires erected so many villas and dined by himself on seven courses? [35]

Cups at banquets are so rare that even if one is ever handed to you, a slave is set as guard over you to count the gems and watch your sharp nails.[36]

Juvenal recalls with despair the olden time Roman soldiers, "too ignorant to admire the arts of Greece who used to break up the drinking-cups, the work of some renowned craftsman . . . whatever silver he possessed was on his armor alone." [37] The only tolerable life indeed was in a country garden far from the luxuries of cities.

Live there enamored of your pitch-fork.[38]

V

DILETTANTISM IN ROME

AS SOON as their moral resistance and their arrogance as conquerors were modified, Roman invaders of Greece became apt recipients of the ancient culture. The havoc of Mummius and Fimbria was then somewhat repaired by the good-will of Paulus Aemilius, Metellus and Lucullus. Paulus Aemilius, for instance, on his return to Rome, was so bold as to have his own sons educated, "not only in those arts then taught in Rome, but also in the genteeler arts of Greece" — including grammar, rhetoric, sculpture and painting.[1] Even Sulla, in the midst of his slaughters, had taken an interest in the Olympic Games and had possessed himself of the writings of Aristotle and Theophrastus, which he caused to be published in Rome.[2] Sulla is said to have been the first to introduce mosaics into Rome, an art which became peculiarly characteristic of Roman taste.[3]

Hence a time was at hand when the study of Greek letters and arts became a part of the better Roman educational equipment. Traveling in Greece, and attendance at the lectures of the Athenian philosophers were practices, as necessary as they were fashionable. Latin writers and orators would pride themselves on their mastery of the Greek language and on their acquaintance with its literature. Myth-makers discovered Rome's association with Greece from time immemorial, told of ancient consultations at the Delphic Oracle by the first citizens of their city, traced the pedigree of their kings from Aeneas, made Numa a disciple of Pythagoras and established a Spartan origin for Roman laws. Every Roman of wealth and taste was a collector of Greek works of art, of Corinthian bronzes, Attalic tapestries, Coan silks, Sicyonian pictures, of gold, silver and marbles.

Julius Caesar affected to be the moralist in his own published writings. He seemed to be scandalized at Lucius Scipio's behavior at Ephesus, where there had been an attempt to remove "the treasures of antiquity"; and the luxury of Pompey's camp after the battle of Pharsalus — Pompey had used silver plate — gave him an

occasion for observations on superfluous and effeminate pleasures.[4] But he spared Athens, who had revolted with Pompey, remarking that she had been saved by her dead and by the glory of her past.[5] He restored Corinth and excavated its ruins. "All the sepulchres were carefully examined for objects of interest" and the pottery and sculptures found were later sold in Rome for high prices.[6] Caesar also showed Troy much favor, in imitation of Alexander and as an admirer of Homer.[7] He built magnificent works in the principal cities of Greece and Asia, as well as in Gaul and Spain. In Rome he cleared a large slum quarter at his own expense and built a forum and temple to Venus on the site. On two pictures for this temple he spent as much as eighty talents.[8] Suetonius says he was always an enthusiastic collector of gems, carvings, statues, pictures and Old Masters (*opera antiqua*).[9] He assigned to Varro, the scholar, the task of providing the public libraries with Greek and Latin authors.[10] He was also a reader and critic of poetry, and compiled a quotation-book (*dicta collectanea*).[11]

Whatever Cicero may have given himself out to be in public, his letters and essays, meant for private circulation among his friends, are full of

the dilettante spirit. His interest in architecture is genuine and supported by as much knowledge as appreciation. He writes to his brother Quintus, then in Britain, of a villa in course of erection for Quintus' residence:

I liked that villa very much because its paved portico gives it an air of very great dignity. I never noticed this till now that the colonnade itself has been all laid open and the columns have been polished. It all depends — and this I will attend to — upon the stuccoing being prettily done. The pavements seem to be being well laid. Certain of the ceilings I did not like, and ordered them to be changed. As to the place in which they say that you write word a small entrance hall is to be built, I like it better as it is. . . . From the very beauty of its arched roof, it will serve as an admirable summer room.[12]

In one place Cicero shows his knowledge of the principle of columns being slightly out of the perpendicular.[13] Cicero is conversant with the functions of the connoisseur and is always respectful of the expert. "How much, unseen by our eyes does the painter see in his shadows and his relief?" (*Quam multa vident pictores in umbris et in eminentia quae nos non videmus?*) he asks.[14] Cicero in his palmy days would often write to his friend Atticus on the subject of statuary. He is even

afraid his appreciation for art treasures will make people laugh at him.[15] Evidently Atticus made purchases for him. "My purse is long enough," writes Cicero, "and this is my little weakness" (. . . *genus hoc est voluptatis meae*).[16]

The following are two quotations, typifying Cicero's interests:

In navigation, what is so necessary to a ship as bulwarks, keel, prow, stern, yards, sails, mast and yet combining so much beauty with their respective configuration, that they seem invented less for the purposes of utility than to charm the eye with their grace and symmetry (*ut non solum salutis, sed etiam voluptatis causa, inventa esse videantur*). In architecture, the columns give support to porticos and temples, and yet are not more useful than ornamental (*Tamen habent non plus utilitatis quam dignitatis*). It was not taste but necessity (*non venustas sed necessitas*) that suggested the roof of the Capitol, or the slanting roof of other buildings; for when the problem of throwing off the rain from both sides of the edifice was solved, the beauty was the consequence of its utility; so that if the Capitol had been built above the clouds, where rain could never fall, no other conformation would have been equally pleasing to the eye.[17]

But who that has seen the statues of the moderns will not perceive in a moment that the figures of Canachus are too stiff to resemble life (*rigidiora . . . quam ut imitentur veritatem*). Those of Calamis,

though evidently harsh, are somewhat softer (*dura
. . . sed tamen molliora*). Even the statues of Myron
are not sufficiently alive (*satis ad veritatem adducta*);
but yet one does not hesitate to pronounce them
beautiful. But those of Polycleitus are much finer
and, in my mind, completely perfect (*pulchriora
. . . et iam plane perfecta*). The case was the same in
painting. In the works of Zeuxis, Polygnotus and
Timanthes, and several others, who confined them-
selves to the use of four colors, we commend the
form and the outline (*formas et lineamenta*) of their
figures; but in Aetis, Nicomachus, Protogenes, and
Apelles everything is done to perfection (*perfecta
sunt omnia*).[18]

Cicero's prosecution of Verres has been noted.
Cicero attacked Verres on that occasion for faults
which he himself possessed in milder measure.
Verres was praetor of Sicily and there had taken
advantage of his power to amass a collection of
works of art and antiques. His usual method,
according to Cicero's speech, was to confiscate
the property of the possessor of some such work
of art as he coveted, on a trumped-up charge.
Verres' artistic tastes became a scandal. Thus
Cicero declaims:

Verres himself calls it his passion; and his friends
call it his madness; the Sicilians call it his rapine;
what I call it, I know not . . . but I say that in all
Sicily, in all that wealthy and ancient province,

there was no silver vessel, no Corinthian or Delian plate, no jewel or pearl, nothing made of gold or ivory, no statue of marble, brass or ivory, no picture painted or embroidered, that he did not seek out, inspect, and that, if he fancied it, he did not carry away.[19]

Verres was a type, though doubtless, even discounting Cicero's hyperbole, normal in his tastes rather than in his methods of satisfying them. Cicero's speeches against Verres reveal a mentality which in the next generation was to be the order of the day, and no longer condemned if its proceedings were within the law. Cicero himself enumerating the generals who conquered Sicily and Greece, said: "We see the whole city of Rome, the temples of the gods, and all parts of Italy, adorned with their gifts, and with memorials of them." [20]

It is probable that Vitruvius, the architect, wrote at this time the work which he afterwards dedicated to Augustus. Inasmuch as he was favored by so exalted a protector, his opinions must have been acceptable to his generation and are therefore an invaluable record of the state of architecture in Rome at the opening of her imperial epoch. A not very literary writer, Vitruvius nevertheless affects to possess encyclopaedic

learning and demands encyclopaedic learning of his fellow architects. He is devoted to his Greek authorities and all his architectural technical terms are supported by a Greek reference. He divides architecture into practice and theory (*fabrica et ratiocinatio*), remarking that both are required in a successful architect. He recommends the study of archaeology for he says: "Unless acquainted with history the architect will be unable to account for the use of many ornaments which he may have occasion to introduce." [21] Vitruvius' architectural practice is prophetic of modern practice. He recognises the function of the draughtsman with his perspectives and rendered drawings, "whereby his delineations of buildings or plane surfaces are greatly facilitated." [22] The following is an example of Vitruvian aesthetics:

The merit of every work is considered under three heads, the excellence of the workmanship, the magnificence and the design (*fabricae subtilitate, magnificentia et dispositione*). When a work is conducted as magnificently as possible, its cost is admired; when well-built, the skill of the workmen is praised; when beautifully, the merit belongs to the architect on account of the proportion and symmetry which enter into the design (*cum vero venustate, proportionibus et*

symmetriis habuerit auctoritatem, tunc fuerit gloria architecti). These will be apparent when he submits to listen to the opinion even of workmen and ignorant persons. For other men, as well as architects, can distinguish the good from the bad; but between the ignorant man and the architect there is this difference, that the first can form no judgment till he sees the thing himself; whereas the architect, having a perfect idea in his mind, can perceive the beauty, convenience and propriety of the design before it is begun.[23]

Augustus instituted in his reign the moral reformation which the previous chapter has described. Nevertheless building on an unprecedented scale was undertaken at his instigation and all arts encouraged, whether or not they were subjected to the rigors of censorship. Augustus' villas were designedly modest — no doubt in harmony with his puritanic restrictions — and decorated, says the historian Suetonius, "not so much with ornate statues and pictures as with terraces, groves and objects noteworthy for antiquity and rarity" (*rebus vetustate ac raritate notabilibus*).[24] But he was criticised for his addiction to gaming and to costly furniture, and to Corinthian bronzes. It was even said that he proscribed men in order to obtain the Corinthian bronzes they had been known to possess.[25]　Evidently Augustus was

not free from the artistic vices of his time. He beautified his empire with architecture, and so far afield as Pergamon a temple was founded in his honor.[26] *The Acts of Augustus* (*Res Gestae Divi Augusti*) gives a list of his works in Rome; in one consulship he restored as many as eighty-two temples. It was his boast that he found Rome of brick and left her of marble.[27]

Augustus' tastes were intensified and vulgarised by his immediate successors. The Emperor Caligula acknowledged no restraints of law, morality or of political discretion. He squandered the exchequer of the state in less than a year, generally over fantastic architectural and engineering schemes. He threatened on one occasion to transport to Rome the Olympian Zeus and to substitute his own likeness for that of the god. He would entertain himself with erudite studies, especially oratory. He so far aped the bearing of Alexander the Great, that he wore the breast plate, rifled from Alexander's sarcophagus.[28] So also Nero rendered his tyranny ridiculous by his artistic and Philhellenic extravagances, singing his own poems in the Greek theatres of Naples, competing for the prize of tragedy at Olympia, patronizing rhetoricians, poets, artists,

dissipating the substance of the state in works of architectural magnificence. He had a particular *flair* for portraits of himself.[29]

The Flavian Emperors have not been blessed with worthy biographers and their adventures in the arts must be judged from the ruins of their buildings — the Colosseum of Vespasian, the Arch of Titus, and the rest. Domitian, says Plutarch, had "the disease of building," and restored the Jupiter Capitolinus Temple on a lavish scale.[30] But the Flavian and the following age was rich in writers, Martial, Statius, Quintilian, Tacitus and the two Plinys, all of whom, in their own degree, express the antiquarianism and the artistic loves of their contemporaries. Martial has his sly cut at the collectomaniac and the faker of antiques.[31] Statius in deliberate seriousness sings the praises of gardens, baths, country villas, temples and works of art.[32] Quintilian, teaching rhetoric, makes long digressions on artistic topics; — the following is an example:

The first great painters whose works deserve inspection for anything more than their mere antiquity, are said to have been Polygnotus and Aglaophon, whose simple coloring (*simplex color*) has still such enthusiastic admirers that they prefer these almost

primitive works (*mox artis primordia*), which may be regarded as the first foundations of the art that was to be, over the works of the greatest of their successors, their motive being, in my opinion, an ostentatious desire to seem persons of superior taste (*proprio quodam intelligendi ambitu*). Later, Zeuxis and Parrhasios contributed much to the progress of painting. These artists were separated by no great distance of time, since both flourished about the period of the Peloponnesian War . . . the first mentioned seems to have discovered the method of representing light and shade, while the latter is said to have devoted special attention to the treatment of line (*subtilius lineas*). For Zeuxis emphasized the limbs of the human body, thinking thereby to add dignity and grandeur to his style. . . . Parrhasios, on the other hand, was so fine a draughtsman (*vero iter circumscripsit omnia*) that he has been styled the law-giver of his art, on the ground that all other artists accept his representation of gods and heroes as models. . . . It was, however, from about the period of Philip down to that of the successors of Alexander that painting flourished more especially, although different artists are distinguished for different excellences. Protogenes was renowned for accuracy (*cura*), Pamphilius and Melanthius for soundness (*ratione*), Antiphilius for facility (*facilitate*), Theon of Samos for his depicting of imaginary scenes, called φαντασίαι (*concipiendis visionibus*), and Apelles for genius and grace (*ingenio et gratia*), in which latter quality he took especial pride. Euphranor, on the other hand, was admired on the ground that while he ranked with

the most eminent master of the other arts, he at the same time achieved marvellous skill in the arts of sculpture and painting.[33]

Tacitus, the historian, reveals a real interest in architecture. He deliberately digresses to describe the peculiarities of the temple of Venus at Paphos.[34] He gives details of the destruction by fire of the Jupiter Capitolinus Temple in the civil commotions which followed Nero's death. On its rebuilding, he remarks that the height of the roof was raised.

This was the only change that religious scruples would allow and it was felt to be the only point in which the former temple lacked grandeur (*prioris templi magnificentiae defuisse creditum*).[35]

The *Annals* take note of building operations and of fires or destructions of buildings. Of the burning of Rome in Nero's reign, Tacitus says:

It would not be easy to compute the palaces, tenements and temples lost . . . the riches acquired by our many victories, the various beautiful objects of Greek art, the ancient and genuine historical monuments of men of genius, — and notwithstanding the striking splendor of the city as it was restored, — old men will remember many things which could not be replaced.[36]

The new city was built, not as it had been after its burning by the Gauls, without regularity or in any

fashion but with rows of streets according to meas-
urement, with broad thoroughfares, a restriction on
the height of houses, with open spaces, and the fur-
ther addition of colonnades as a protection to the
frontage of the blocks of tenements.[37]

Pliny the Elder's *Natural History* comments
incidentally upon art and artists. Pliny was a
compiler of excerpts from other writings which he
seems to have gathered without discrimination
and accepted without criticism. When he bor-
rows from the puritans he is puritanical and
decries the luxuriousness of his age; when he
borrows from the primitives he is all gold-and-
glitter in his tastes; when he borrows from the
dilettante he is himself a dilettante. Hence he
often harks back to the vigorous poverty of his
ancestors and deems that the frequent fires in
Rome are the just punishment meted out by the
gods upon a vicious generation. He is particu-
larly harsh on the subject of gems and jewellery.[38]
Yet again he waxes ecstatic about the beauty of
gems and imagines them to contain the absolute
perfection of Nature.[39] He says Mummius filled
Rome with Greek sculpture and he adds: "I must
say in his favor that he died too poor to leave
his daughter a dowry." Yet in the *Preface* of his

work he declares he was never tired of admiring Greek art. He is full of imitation crudities, such stories as of paintings of fruit attracting the very birds, of paintings of snakes acting as scare-crows, of paintings of horses at which the real horses neighed. Yet an advanced criticism exists, as the following selections may show:

Parrhasios first gave painting symmetry, added vivacity to the features, daintiness to the hair and comeliness to the mouth, while by the verdict of artists he is unrivalled in the rendering of outline. This is the highest subtlety attainable in painting. For merely to paint a figure in relief is no doubt a great achievement. Yet many have succeeded thus far. But where an artist is rarely successful is in finding an outline which shall express the contours of the figure. For the contour should appear to fold back, and so enclose the object as to give assurance of the parts behind, thus clearly suggesting even what it conceals. (*Primus symmetrian picturae dedit, primus argutias voltus, elegantiam capilli, venustatem oris, confessione artificum in lineas extremis palman adeptus. Haec est picturae summa subtilitas. Corpora enim pingere et media rerum est quidem magni operis sed in quo multi gloriam tulerint, extrema corporum facere et desinentis picturae modum includere varum in sudcessu artis invenitur. Ambire enim se ipsa debet extremitas et sic desinere ut promittat, alia post se ostendatque etiam quai occultat.*) [40]

(78)

To admire art we need leisure and profound still-
ness (. . . *quoniam otiosorum et in magno loci
silentis talis admiratio est*). [41]

Pliny had a finished conception of art history
and spoke with familiarity of styles, — "*Tus-
ciana*," "*antiquissima*," etc. He had the modern
connoisseur's contempt of modern art, which he
contrasts with the resplendent days of old:
"worthy of the old masters" (*antiquorum dig-
nam fama*) [42] is the zenith of praise. He notes
faithfully the enormous prices works of art fetched
at his time. Corinthian bronzes were so prized
that some owners carried them about. A can-
delabrum, he says, would command as much as a
year's pay of a military tribune.[43] He speaks of
art critics and experts (*peritiores artis*) and he is
equal to all the tricks of the faker of antiques and
jewelry.

Pliny the Younger, nephew of Pliny the Elder,
is a more polished and consistent character, and
all his ideas are his own. His letters reflect a cul-
tured, erudite age, somewhat parallel to Georgian
England, with its learned artistocratic circles,
steeped in classical lore, enjoying the amenities
of the country-life, spending their superfluous
moments in the flattery of their sovereign and

of one another. The letter describing the virtues of a certain Spurrina represents the atmosphere well. At Spurrina's villa "you sit down," he writes, "to an elegant yet frugal repast, which is served up in plain and antique plate. . . . He likewise uses dishes of Corinthian bronze, which is his hobby not his passion." The conversation at table is literary.[44] He gives full descriptions of his own villas, their approaches, the scenery of their setting, the views they command, the disposition of their arrangements, their furniture, elegancies and pleasures — and of course there is the atrium built therein "after the manner of the ancients" (*ex more veterum*).[45] He writes again elsewhere:

We are all eagerly awaiting the sale of the effects of Domitius Tullus. For he was so great a collector that he adorned a vast garden with a quantity of antique statuary the very day he purchased it.[46]

He describes a certain spot to a friend where, he assures him, everything will afford entertainment, and where there are numerous inscriptions to read.[47] Of travel he says:

Those works of art or nature which are usually the motives of our travels by land or sea, are often overlooked and neglected if they lie within our reach . . .

there are several varieties in and near Rome which we have not only never seen, but never as much as heard of; and yet if they had been the produce of Greece, Egypt or Asia, we would have long since heard of them, read about them, and seen them for ourselves.[48]

He describes his purchase of a Corinthian bronze.

It is small, but pleasing and finely executed, at least, if I have any taste. . . . I think even if I have knowledge enough to discover the beauties of this figure. . . . (He then proceeds to observe the realism of the modelling and the technique of the anatomy). It appears to be a genuine antique, alike from its tarnish and from what remains of the original patina. In short, it is a performance so highly finished as to fix the attention of artists and delight the ignoramus; and this induced me, who am a mere novice in this art, to buy it. (*Aerugo aes ipsum, quantum versus color, indicat vetus et antiquum, talia denique omnia, ut possent artificium oculos tenere, delectare imperitorum. Quod me quamquam trunculum sollicitavit ad emendum.*) [49]

Pliny the Younger died about 114 A.D. Rome was in her heyday. Trajan was emperor and his reign was marked by prosperity and great works. Pliny was for a time prefect of Asia and wrote to Trajan on the building schemes under his jurisdiction, temples, forums, aqueducts, canals. Trajan's successor, Hadrian, traveled the whole

Empire. He treated Greece with uncommon re-
spect, and restored its shrines. He completed the
great temple of Jupiter in Athens. Pausanias
constantly praised Hadrian for his pious generos-
ity in Greece. Hadrian's addiction to Greek stud-
ies earned him the nickname of "Graeculus." [50]
He was versed in poetry and was an expert in
mathematics and painting. He boasted of his
knowledge of music, and wrote love-poems, gen-
erally to his favorite Antinous.[51] He wrote an
autobiography and affected literary archaisms.
He presented plays "in the ancient manner." [52]
He was generous towards artists and teachers
but is said to have been addicted to argumenta-
tion in their presence.[53] On his return to Rome
he built a great villa at Tivoli, which was in the
nature of an imperial museum and accommodated
the curiosities which he had collected on his tour.
Parts of the villa were named after provinces and
places, as the Lyceum, the Academy, Prytaneum,
Canopus, Poecile, Tempe and even Hades.[54]
Probably the villa was a miniature world, or at
any rate a miniature reproduction of the Roman
Empire.

Among the last of the imperial dynasties, the
Severi have left great works. The baths of the

Emperors Caracalla and Diocletian are permanent symbols of Roman magnificence, even in their present ruin. Diocletian terminated the series with his palace at Spalato. Constantine, the first Christian Emperor, removed his capital to Byzantium, which he equipped as a vast museum of Greek art. But Constantine properly belongs to another age.

VI

CLASSIC AND ROMANTIC PHASES
IN ANTIQUITY

ACCORDING to accepted definition, Classicism in literature and art has to do with some rational state of mind, and Romanticism with some irrational, hence emotional, state of mind. Unfortunately Classicism has come to be associated with antiquity and Romanticism with the eighteenth and nineteenth centuries A.D. Actually antiquity had both Classic and Romantic phases — two definite, consecutive phases, which most certainly justify the use of those names.

Greek art in the archaic and middle (fifth-century), periods was *par excellence* a Classical art. The whole mentality of the age, whenever it expressed itself, in morality, philosophy and literature, was, in a sense, consistently rational. Philosophers studied mathematics and attempted by logical methods to understand the

mystery of things. Pythagoras built up a whole system on a theory of Number. Works like Plato's *Parmenides* were significant of their time. Art and Science were then indistinguishable. One word, τέχνη, sufficed for both. All the arts tended to become subject to laws and traditions of mathematical inflexibility. Polyclitus, the sculptor, is supposed to have subscribed to a belief in a mathematical theory of proportions for the human figure. He modeled a statue to embody his conception of the perfect canon of proportions.[1] Xenophon's *Oeconomica* has remarks upon the excellencies of invariable order. "Even pots and pans, arranged in order (εὐκρινῶς κειμέ-νας)," says one passage, "are fair and graceful."[2] To Aristotle art was a certain logical faculty of the mind, using its powers to practical effect. He applies the word "wisdom" (σοφία) to all arts, including, as he says, the art of sculpture.[3] Speaking of the beautiful and the good in general, he says:

Those people are mistaken who affirm that the mathematical sciences teach nothing of beauty and goodness. . . . The main elements of beauty are order, symmetry and definition, and these are the very properties to which the mathematical sciences draw attention (τοῦ δὲ καλοῦ μέγιστα εἴδη τάξις καὶ συμμετρία

καὶ τὸ ὡρισμένον, ἃ μάλιστα δεικνύουσιν αἱ μαθηματικαὶ
ἐπιστῆμαι).[4]

It is indeed probable that Greek buildings were
constructed according to some mathematical for-
mula, and archaeologists are still intrigued by that
probability. There appears to have been a regu-
lar architectural technical literature, honored by
the names of such authors as the architects of the
Croesus temple at Ephesus, and Ictinus, architect
of the Parthenon; and this literature was essen-
tially a literature on measurement.[5] The archi-
tectural "refinement" again must have demanded
a considerable science. The Orders of Vitruvius
in Roman times were a reflection of these condi-
tions. It is noteworthy that whenever Vitruvius
cites a Greek authority, he is making a purely
technical reference.

One result of the Classical outlook was the sup-
pression of individual invention. Traditionalism
was all-powerful, and any novelty was an out-
rage. Plato congratulates the Egyptians on the
unalterable traditions of their arts, which he be-
lieved to have been first designed by the Gods for
the edification of mankind.[6] He recalls the rigid
musical traditions of his own ancestors.[7] Hence
the individuality of the artist was reduced to a

(86)

minimum. The following curious passage in Plato is evidence of the possibility of several artists engaging successively upon one work, oblivious of their individualities:

Suppose that someone had a mind to paint a figure in the most beautiful manner in the hope that his work instead of losing would always improve as time went on — do you not see that, being a mortal, unless he leaves someone to succeed him, who will correct the flaws which time causes and who will be able to add what is left imperfect through the defect of the artist and who will brighten up and improve the texture, all his great labor will last but a short while.[8]

Aristotle believed that the artist should obliterate all traces of himself in his work.[9] It was noted above how innocently Thucydides makes Pericles suppose that, if the gold plates of the Athena Parthenos were destroyed, they could be replaced.[10] Contrast these with a passage in Pliny the Elder, writing at another time, when such sentiments had passed away.

Another curious fact and worthy of record, is that the latest works of artists and pictures left unfinished at their death are more admired than any of their finished paintings. . . . The reason is that in these we see traces of the drawing and the original conception of the artists (*quippe in iis lineamenta reliqua ipsae-*

que cogitationes artificum spectantur), while sorrow for the hand that perished at its work beguiles us into the bestowal of praise.[11]

Pliny records that the picture, which Apelles left unfinished at his death, no one dared touch again.[12]

The breaking down of traditionalism and the emergence of the individual artist occurred from the fifth century onwards. It was marked surely enough by the gradual disappearance thereafter of the Classical spirit in the arts. The first sign was the acknowledgment of the artist's personality and a betterment of his intellectual and social condition. In very early antiquity the artist was not even known by name. Homer mentions his mortal brethren in the art of poetry and song, but otherwise the only artist he deigns to mention is a ship-builder.[13] Herodotus and Xenophon begin to mention artists. Plato and Aristotle refer to artists and their works. Evidently the artist's status in society was low at first. It is very appropriate that the god, Hephaestus, was a despised cripple and was more than once insulted at the court of Zeus. By a superb irony, mythology married him to Aphrodite, who appears not to have been a respectful or obedient

wife. The mythic Daedalus on the other hand seems to have been a bit of a courtier. Xenophon in the *Oeconomicus* held the "mechanical" arts in poor repute. "Men engaged in them," he says, "must ever be both bad friends and feeble defenders of their country." He troubled himself little with those skilful in carpentry, metallurgy, painting and sculpture, but he was always anxious to meet a "gentleman" (καλός τε κάγαθός).[14] Yet Socrates, into whose mouth Xenophon puts these opinions, is said to have been a sculptor in his youth. The sculptor, Pheidias, Socrates' older contemporary, was among the chosen friends of Pericles and could have been no mean character in the social scale. But Pheidias was probably exceptional and owed his recognition to the liberality of Pericles. It is strange that the actor in Athens was generally considered a respectable person, — dramatists and orators were often actors, — for this profession has been despised the world over. In Rome actors were among the most depraved of her citizens.

So soon as the artist's condition improved, both the artist and his art attained to a rank of respectability. Many of the painters became wealthy men. Parrhasios was noted for his luxury

and used to call himself Ἀβροδίαιτος, the Luxu-
rious.[15] Zeuxis amassed a fortune.[16] Apelles was
a kind of Titian, a friend of princes and a confi-
dant of kings. He had the daring to censure
Alexander the Great's *faux pas* in art-criticism.[17]
Alexander favored him by giving him his mis-
tress.[18] Lysippus was Alexander's sculptor by
appointment and alone was permitted to model
the royal likeness.[19] Then the arts were practised
as social accomplishments by the leisured ama-
teur. Painting was taught to free-born youth
in Greece as a part of a liberal education, an
innovation due to the influence of Pamphilos,
the master of Apelles.[20] In Rome in the time of
the Emperors painting was cultivated in high
social circles. A dumb boy of good birth, the
grandson of a consul, was taught painting by the
special consent of Augustus. Turpilius, a Roman
knight in Pliny the Elder's lifetime, used to
paint.[21] Vitruvius presents the picture of the
Roman architect in full-blown professional status.
Cicero appears to have been on good, if imperious,
terms with his architects.

There seemed also to be a delight in anecdotes
about the eccentric artist. Zeuxis, the painter,
would wear his name woven in golden letters on

the hem of his garments when he attended the festival at Olympia.[22] Parrhasios was known for his easy-going good-nature; and is said to have sung as he worked. He used to write epigrams on his own pictures.[23] Dinocrates, the architect, obtained the notice of Alexander by his appearance and apparel. He was tall and handsome, and, after the example of Heracles, bore a lion-skin, a wreath of poplar and a club.[24] Hippodamos, another architect, affected flowing locks and expensive ornaments, and was jealous of his reputation for universal learning.[25] Nicias, the painter, was so absorbed in his work that he would forget his food.[26] Protogenes continued to paint undismayed during the siege of Rhodes.[27] He once took seven years over one picture.[28] Apollodorus was so severe a critic of himself that, unable to attain his ideal, he would destroy the labors of days. People used to call him the "Madman."[29] Pasiteles, the Graeco-Roman sculptor, was nearly killed in an adventure with a lion, which he was modeling from the life.[30] Famulus treated his art with such seriousness that he only worked a few hours a day and then always wore a toga;[31] — a story reminiscent of the French *littérateur*, who never wrote his native language

except in his dress clothes. Ovid complains that poets in his time were thought to be mad (*an populus vere sanos negat esse poetas*). [32]

The emergence of the individual was furthermore marked by an interest in individuality. Men came to regard themselves and their fellows as objects of curiosity. Hence the discovery of the "character" in art. The old drama, with its heroic characters, by Aristotle's definition concerned "universals," but the later drama concerned "particulars," that is, individual men. [33] Euripides gave slaves important parts in his tragedies — a concession to human nature, which Aeschylus would not have dreamed of. The rise of the art of comedy was symptomatic. Comedy, according to Aristotle, is imitation of men worse than the average. [34] In the third century A.D., when comedy was worn threadbare, Plotinus wrote:

We are censuring a drama because the persons are not all heroes, but include a servant, a rustic and some scurrilous clown; yet take away the low characters and the power of the drama is gone; these are part and parcel of it. [35]

Theophrastus reflects the same interests in his work, the *Characters*. Theophrastus declares

himself to be a student of human nature (τὴν ἀνθρωπίνην φύσιν).[36] Dicaearchus, a friend and colleague of Theophrastus, has left some fragments of a travel-book, notable for descriptions of types of character. Strato, a philosopher, a successor of Theophrastus as head of the Peripatetic School, wrote a treatise on Human Nature, now lost.[37] The interest in biography and the creation of the novel, the secular romance, were other signs of the times.

In sculpture and painting human interests were represented by the Alexandrian realists, and by such works as the famous Old Woman of that time. There were also in Graeco-Roman times sculptures of cripples, notably the Aesop, from whose misshapen form his disease can be diagnosed to-day. Contrast this Aesop with the sculptures of the fifth century B.C., in the days when nothing but the traditional perfect was allowed — when Alcamenes executed his Hephaestus at Athens, "the lameness of the god was so tactfully suggested that it was patent without amounting to deformity." [38] Pliny's *Natural History* mentions a whole school of *genre* painting. Hence a certain Peiraecus painted barbers' shops, cobblers' stalls, asses, eatables and so forth. He

was called Ρυπαρογράφος, "a painter of odds and ends." [39] Studius, contemporary with Augustus, painted fishermen, fowlers, hunters, vintagers, and other subjects of "vivacity and humor." [40] The wonderful characterization of Roman portrait sculpture would be fittingly classed in this same group.

Another movement in Fine Art, somewhat antithetic to the "character" school, but arising like it in the mental atmosphere of the time, was the allegory. This also would perhaps depend upon the freedom of the individual. A kind of private meditation, not controlled by the didactic and collective religion of previous centuries, was doubtless responsible for the mental abstraction which could represent serious and philosophic themes as allegories. Such works were executed as Apelles' Calumny,[41] Lysippus' Opportunity, Euphranor's Good Luck, Valor, Hellas,[42] Aëtion's Tragedy and Comedy.[43] There were a number of statues impersonating cities — Rome, Athens, Antioch and so on.[44] The "ideal" busts, Homer, Hesiod, and others, date from this period. The "symbolical" interpretation of sculpture is found in such writers as Philostratus and Plotinus.[45] All this would be expected in an age when re-

ligion, if it existed at all, was completely intellectualised, when it was customary to defend the old myths by referring to allegorical interpretations, and when a certain scientific and rationalistic spirit, such as must have prevailed in the Museum and libraries of Alexandria, habituated men in abstract introspective thinking. If gods and goddesses did appear, they were little more than artistic conventionalities. "The poets," said a Graeco-Roman writer with all the innocence of irreligion, "introduced gods into their scenes for the sake of nobility and gravity, and the painters have done likewise." [46] Such a man would construct a story with the assistance of his gods, as readily as would a Renaissance architect lay out a garden with his nymphs and Tritons.

The artist, now an individualist, would next seek to infuse his works with his individuality. In the last centuries of antiquity, therefore, there arrives much discussion of the topics of novelty and originality. The rigid traditional Classicism of the past was irretrievably set aside. No longer was Imitation the aim of Fine Art, but instead Imagination, the φαντασία, "a wiser and subtler artist," preached by Philostratus. Artists at last "expressed themselves" in true Romantic vein;

they avoided the mildest hint of plagiarism as a virulent disease. In literature, rhetoricians were already propounding the virtues of originality before the Christian era. The continual literary disputes at Alexandria were substantially pretensions to originality and denials of plagiarism on the part of the disputants. It was then the fashion to strike out on new lines and hit off sudden effects. Longinus, an author probably of the third century A.D., appears to have been up to date in everything except that he loathed "all these undignified faults in literature . . . the craving for intellectual novelties, over which our generation goes wild." [47] Lucian claimed to be an original author and the inventor of a form of tragedy, which he justified in his *Literary Prometheus*, itself a significant title. He also wrote a dialogue on originality in the Fine Arts, discussing its merits and demerits.[48] Cicero, praising a speech, says: "Such a torrent of the choicest language . . . so true, so new (*tam novae*), so free from puerility!" [49] In rhetoric, says Quintilian, "the young should be daring and inventive, and rejoice in their inventions . . . exuberance is easily remedied, but barrenness is incurable. For the critical faculty should not develop before the

imagination." [50] Invention (*inventio*) was one of
the parts of oratory; both Cicero and Quintilian
wrote on its functions. Martial satirized poetical
plagiarism.[51]

In painting, the spirit of individuality was
manifest in the painter, Zeuxis, who, it is said,
when he had established his supremacy, seldom
painted the usual myths, but was always intent
on novelty. "He would hit upon some extrava-
gant or strange design, and then use it to show
his mastery of his art." [52] Lysippus, the sculptor,
on one occasion, working for Cassander, who had
conceived the ambition of inventing some pe-
culiar kind of utensil of earthenware, "brought a
number of cups of every imaginable shape, and,
borrowing a bit from each, made one goblet of a
design of his own." [53] Lysippus claimed to be no
man's pupil. By early training a coppersmith,
he was encouraged and patronized by a painter,
whose dictum was: "Follow no artist but Na-
ture." [54] Lysippus believed himself to differ from
older artists in that they represented men as they
were, and he as they appeared to be.[55] Apelles
used to say that he surpassed his contemporaries
in one point, namely, in knowing when to stay his
hand; for his rival, Protogenes, was noted for his

over-industry and anxious elaboration.[56] One of
Apelles' pictures of Aphrodite was especially cele-
brated because only the head was finished, the
remainder being left rough.[57] Evidently Apelles
was a kind of impressionist. Athenaeus wrote in
one place:

> Since novelty has a very great effect in making a
> pleasure appear greater, we must not despise it, but
> rather pay great attention to it. . . . For all these
> things, (sweet-meats, perfumes, cups, furniture, etc.)
> contribute some amount of pleasure, when the ma-
> terial which is admired by human nature is properly
> employed; and this seems to be the case with gold
> and silver, and with most things which are pleasing
> to the eye and also rare, and with all things which
> are elaborated to a high degree of perfection by man-
> ual arts and skill.[58]

Cicero comparing the individualities of artists
wrote:

> There is only one art of sculpture in which Myron,
> Polyclitus and Lysippus were eminent; they are all
> unlike each other, and yet are their works so excel-
> lent that you would not wish any one of them to be
> other than he is . . . Zeuxis, Aglaophon, Apelles are
> most unlike, though in none is there a perceptible
> absence of any requisite of his art.[59]

Pliny speaks of the "originality" of painters and
sculptors.[60]

The genius controversies, such as exercised the wits of the learned in the eighteenth century, were questions of the day. Longinus is familiar with the conception of genius. "The lofty tone is innate," he writes, "and does not come by teaching; nature is the only art which can compass it." [61] Longinus also discusses the old argument that the works of genius are not always above faults; yet those very faults are more worthy of admiration than the dull orthodoxy of the lesser artist. "I am well aware," he writes, "that genius is not perfect, for invariable accuracy is often petty; but in the sublime, as in great fortunes, there must be something overlooked." Does the faultless Eratosthenes, he asks, prove himself to be a greater poet than Archilochus, "with that rich and disorderly abundance which flows in his train, and with that outburst of divine spirit within him, which it is so difficult to range under a law?" (πολλὰ καὶ ἀνοικονόμητα παρασύροντος κἀκείνης τῆς ἐκβολῆς τοῦ δαιμονίου πνεύματος, ἣν ὑπὸ νόμον τάξαι δύσκολον.)[62] There were also the freedom controversies, that self-expression is untrammeled by restraint, that the Muse is most happily entertained and most bounteous when genius is unvexed. "Poetry enjoys unre-

stricted freedom;" writes Lucian, "it has but one law, the poet's fancy." (ἐκεῖ μὲν γὰρ ἀκρατὴς ἡ ἐλευθερία, καὶ νόμος εἷς, τὸ δόξαν τῷ ποιητῇ.)⁶³ "If rules constitute an orator," asks Cicero, "who may not be an orator, for who cannot learn rules with more or less ease?" ⁶⁴ Pliny the Elder talks about artistic caprice (*impetus animi et artis libido*).⁶⁵ Quintilian said of his own art: "The life-blood of the imagination must not be exhausted by dry technical studies." ⁶⁶ Finally Plotinus evolved a whole philosophy in defence of the irrational. He supposed that this philosophy was founded upon the rational mysticism of Plato. Not Reason, as in Plato, but Unreason was to Plotinus the true principle for the comprehension of philosophic truth, of Beauty and of Fine Art.

The exaltation of the irrational, the renunciation of artistic law, produced that emotional sentimentality which is commonly associated with Romanticism. Romantic art appreciation was the order of the day. The following is a rhetorical essay, written at this time, reminiscent of the archaic imitation appreciations, but very obviously tinctured with Romanticism. The rhetorician in question addresses a statue of Aphrodite:

O living loveliness in a lifeless body, what deity fashioned thee? Was some goddess of persuasion, or a Grace, or Eros himself the parent of thy loveliness? For truly nothing is lacking in thee. The expression of thy face, the bloom of thy skin, the sting in thy glance, the charm of thy smile, the blush on thy cheeks, all are signs that thou canst hear me. Yea, thou hast a voice ever about to speak. And one day it may be that thou wilt even speak. But I shall be far away. O loveless one and unkind! O faithless to thy faithful lover! To me thou hast granted not one word. Therefore I will curse thee with that curse at which all fair ones always shudder most. I pray that thou mayest grow old! [67]

There is much sentimentality in Lucian's famous reconstruction of his ideal of perfect womanhood from the types of the most famous Greek statues.[68] And occasionally is met that kind of hysterical adoration of works of art, which at the present time is considered somewhat commendable. Lucian speaks of "silent transport and the clasping of ecstatic hands" (καὶ τὴν χεῖρα ἐπισεῖσαι, καὶ καθ' ἡσυχίαν ἡσθῆναι).[69] There is plenty about Passion (πάθος) in Longinus.[70] Statius, the Latin poet, thus rhapsodizes over a friend's villa:

Not though Helicon should vouchsafe to me all her waters, or Pimplea more than quench my thirst; not though the hoof-mark of the flying steed should bounteously refresh me, and chaste Phemonoe un-

lock for me her secret springs . . . could I with hallowed strains sing worthily the countless graces of this spot! [71]

Pathetic it is that all this aesthetic bravery in the Graeco-Roman era should end in pessimism. The artist was free indeed; his arts exalted to all but a divine office. Yet there seemed to be a regretful longing for the rigid Classical past. The artist would fain go back and attempt to express his melancholy reminiscences in revivals of bygone styles. Hence the so-called "archaistic" schools of the Graeco-Roman sculptors, and the deliberate imitation of the conventionalities and formalities which the "archaic" sculptor carved in all ignorance and innocence of heart. But a spirit of disillusion was abroad. Longinus speaks of "the world-wide barrenness of literature that pervades our life." Porphyry, comparing an archaic statue to a contemporary one, writes: "the archaic one though simply executed was considered divine, but the modern might be a wonder of elaborate workmanship though it gives less conviction as a representation of the deity it portrays." [72] "What are we to say," asks Cicero, "if an old picture of a few colors delights some men more than a highly finished one?" [73] Petronius,

the dilettante of Nero's court, was hopeless of the decay of Fine Art. "The greed of money, the glint of gold and silver," he said, "are more admired than the beautiful works of Apelles and Pheidias." [74] Pliny was always harping on the decay of Fine Art. "In the past," he declared, "when artists used only four colors, painting was greater; but now, when India herself contributes the ooze of her rivers and the blood of dragons and elephants, no famous picture is ever painted." [75]

At this point the history of aesthetics in antiquity may be said to close. The non-speculative part of this essay's programme is accordingly completed. The next and last chapter must be devoted to the more speculative aspects; and the author may be excused if he now throws off the pretence of writing history and reveals what is to him the meaning and moral of this aesthetics of antiquity.

VII

CONCLUSION

THE foregoing essay has sought to develop an argument whose nature and implications have not been generally realized. It has discovered, in effect, the existence of an Unacknowledged Problem in Ancient Art and Criticism. In so far as any statement of fact can be destructive, this essay has been destructive. It has criticised the notion of the Greek Ideal, the notion that the fifth-century Greek devoted his life and soul to the adoration of beauty. It has asserted on the contrary that the aesthetic consciousness had hardly troubled the Greek mind in the fifth-century at all. It has quoted in support of these assertions such evidence as is now accessible. Finally it has given to Hellenistic Greece and Imperial Rome the credit of being the homes of true and genuine aesthetic feelings, such as the modern mind can understand.

During the revival of Greek studies in the

eighteenth century, Winckelmann divided the history of Greek culture into three periods: the archaic, the mature and the decadent. The mature period was the fifth century B.C., the Golden Age of Pericles, when the dramas of Sophocles were performed and the Parthenon was built. Winckelmann fancied that to such heights has the genius of man never before or since risen, and that at no time before or since has the sense of beauty been so pure and so prolific. Winckelmann's doctrine was enthusiastically accepted. It has held good to this day. But no attempt has ever been made to reconcile such a doctrine with the complete absence of aesthetic references in writers such as Herodotus and Thucydides, and with the inadequate and disappointing aesthetic references to be found in later writers such as Plato and Aristotle. The fragmentary condition of Greek literature to-day is admitted; the danger of the *argumentum ex silentio* is also admitted; but it is at least pardonable to argue from the data which the said writers supply that the Golden Age of Pericles was not conscious of the sense of beauty and had no aesthetic feelings worth mention. That Pheidias designed his images for the "adornment" of Periclean Athens

is a supposition which Pheidias himself would hardly have appreciated, or which he would have taken more likely as an affront to his piety.

When a race of men has that ancestral faith that can see gods and demons in every little avenue of life, in the sky, the sea, the country side, aesthetic notions must be as foreign to the soul as a philosophy of rationalism. It is only when gods and demons are outgrown and when men begin to think, as modern men think, that a beauty is discovered which before was unknown or hidden. It is appropriate that the first flicker of aesthetics, however dim it was, should have been struck by the rationalist Euripides. The genius of fifth-century Greece was truly medi-aeval. Only in late, or "modern," Greece could aesthetic feelings come to life. In decadent, ir-religious Rome and Alexandria aesthetic feelings flourished as never before.

An analogous problem, the Greek attitude to Nature, used some years ago to be much dis-cussed. The fact became generally accepted that the Greek of the time of Homer, of the Lyric poets and of so late a date as Plato, had very little consciousness of the beauty of Nature. Nature-lore first blossomed in the Natural History books

of Aristotle, and then in the poems of Theocritus. Much the same, it was argued, was the case of the Greek sense of humor. From Homer to Aristophanes, humor was mere ribaldry. With Plato and Menander humor assumed more modern refinements. The aesthetic sensibility of ancient Greece as regards Fine Art, Nature and the Ludicrous, therefore followed a symmetrical history.

But the problem does not conclude here. To argue that the memory of ancient Greece has been so long cherished for qualities it did not possess is perhaps entertaining. To discredit an old established myth is at least commendable. But the present problem involves the very credentials of modern aesthetics and casts a doubt on the accepted faith of many art-workers and art-lovers nowadays. For may it not also be true that the modern sense of beauty, heretofore so universally unquestioned, should, like the ancient sense of beauty, be a changeable and almost evanescent myth? Who was the first man to admire a Work of Art in modern times or call himself an Artist? The aesthetics of antiquity may be a type to which modern aesthetics conforms — using the word "modern," in this instance, as

signifying anything later than the date of the extinction of the ancient Roman Empire.

What was the fate of aesthetics in the early Christian Era? The time then was a time of transition to a new order of things. A new people were procreated and, like the Heracleidae of old, were founders of a new culture. For them there was at first no aesthetics. Comparatively barbarous, they had no use for the finesses of the ancient civilization. The traditions of Rome, it is true, lingered on fitfully. Popes and Emperors and every would-be potentate of the next fifteen centuries aped the style of Caesar. Christianity constantly naturalized into herself the myths and ceremonial of the old Paganism. In the arts, especially in architecture, the early Christians knew not, or cared to know, of any other exemplars than those of antiquity. Churches were built on the plan of the basilica, replete with Pagan types of carving, fresco and mosaic. Temples were reconstructed to serve Christian usage as often as they were delivered over to the malice of fanatics. But the old sophisticated aesthetics was gone.

Hence Lucian, Plotinus and their fellow thinkers found lesser hearing as Christianity spread

and established itself. Only a few of the Eastern
saints and scholars cultivated spasmodically the
old aesthetics without disloyalty to a good con-
science; but they were exceptional.[1] The stark
Christianity of the Iconoclastic Controversy fin-
ally put an end even to these last lingering aes-
thetic remnants. The early Christian more
readily devoted himself to indictments of Pagan
idolatry and of the idolatrous lusts of his early
communities than to the admiration of Fine Art.
The very Gospels, in their one and only mention
of the beauty of architecture, seemed to convey
the reproof of Christ, a reproof symbolic of the
mood and temper of the centuries to follow.[2]

St. Augustine before his conversion confesses
to the authorship of a treatise *On the Beautiful
and Fit* (*De Pulchro et Apto*). In it he had dis-
cussed "lines and colors and masses" (*linea-
menta et colores et tumentes magnitudines*), and
had apparently evolved a regular aesthetic phi-
losophy. After his conversion he rejected the
treatise in horror and counted it among the many
vanities of his heathen youth.[3] St. Augustine in
this instance gives in a small compass an image
of the wholesale aesthetic renunciation of his age.
Early Christianity unconditionally renounced

Fine Art as Fine Art. In other words, early Christianity again conjured up the moral resistance of olden time and added to it the aspect of new terrors. Even later, when the first flush of this early violence was softened, the only excuse for the arts was education. Sculpture and painting found their way again into places of worship, but were used for religious instruction. St. Gregory is famed in modern days as the type of Christian vandal, zealous to root out idolatry and heathenism. But he would allow images on the plea of their educational value. Hence he wrote:

To adore a picture is one thing, but to learn through the story of a picture what is to be adored is another thing. For what writing is to them that can read, a picture is to them that cannot read but can only look. . . . [4]

With the unanimous ratification of the Second Council of Nicaea, the use of images in churches was encouraged:

For by so much more frequently as they are seen in artistic representation, by so much more readily are men lifted up to the memory of their prototypes, and to a longing after them.[5]

But even thus recognised and adopted, the course of Christian art was no smooth one. The

monastic reformations of later generations con-
stantly reminded the Christian world of the aes-
thetic intolerance of the early Fathers. Hence as
late as the thirteenth century, on the eve of the
Renaissance, the gentle St. Francis was reproving
a disciple, who had been so bold as to desire a
little building for the greater convenience of per-
forming the Divine Office and for the quiet and
peace of friars who came as guests. St. Francis
preferred that the friars of his house should suffer
privation for the love of God, than that they
should set an example for spacious and super-
fluous buildings.[6] Building he believed to be a
worldly pursuit, most heinous and ungodly.[7] So
he directed that the cells of his friars should be
made of wood and mud only, for the better safe-
guarding of poverty and humility. "We most
willingly dwelt in poor little abandoned churches,
and we were simple and subject to all," he said.[8]
Such was the spirit of early Christian austerity.

With this parsimonious sanction did the great
art of Gothic come into being. In effect, aes-
thetics had been so completely crushed out, by
the pressure of the Christian moral resistance,
that its history had need to begin again from the
beginning. The archaic gold-and-glitter in its

familiar form first gradually reëmerged. The early sagas, like Homer of old, told the tales of brave deeds, lordly living, bejeweled armor and golden halls:

> There in the olden time, full many a thane,
> Shining with gold, all gloriously adorned,
> Haughty in heart, rejoiced when hot with wine;
> Upon him gleamed his armor, and he gazed
> On gold and silver and all precious gems;
> On riches and on wealth and treasured jewels,
> A radiant city in a kingdom wide. . . .[9]

The appetite of a barbaric age would naturally be whetted by the proverbial gold-and-glitter imagery, when even kings were dwellers in poverty and dreamed of more comfortable possessions. But the later Middle Ages, no doubt, more successfully substantiated these dreams, and from that time there has come down many a written account of the wealth of churches, monasteries and castles, testifying to the mediaeval taste for ostentation and display. But of Art as Fine Art there is the same silence as characterized the early Greek. In architecture, good building was demanded; in sculpture and painting, living realism; in decoration, gold-and-glitter. But a notice of self-conscious formal beauty

never disturbs the innocence of mediaeval documents; and apparently a great age of artistic activity labored and achieved much, and little knew the glory and perfection of its works.[10]

The few "artistic" documents, such as those of Villars de Honnecourt, were late in date and even then are disappointing. They are chiefly technical note-books, occasionally enlivened by a religious exhortation. They are now famed and consulted only because of the complete absence of anything more informative.[11] Chroniclers and travelers write often of churches visited, but without much architectural comment. Relics and miracles appear to engage their attention more. From the travel-books of the earliest pilgrims to the Holy Land, to the works of such world-travelers as Friar Odoric, Marco Polo, Maundeville, men of undeniable gifts and educated in the culture of their time, there is no adequate evidence of the appeal of artistic beauty outside of the extrinsic beauty of luxury and riches.[12] To Friar Odoric, for example, the main objects of interest to a traveler were the grave of St. Athanasius, the mountain where Noah's ark was said to have rested, the supposed remains of the Tower of Babel, and the sites of

martyrdoms and miracles. But the following passages on works of art are also found in his story:

There is in the kingdom of India a certain wonderful idol, which all the provinces of India greatly revere. It is as big as St. Christopher is commonly represented by our painters, and it is entirely of gold, and round its neck it has a collar of gems of immense value, and the church of this idol is also of pure gold, roof and walls and pavement. People come to say their prayers to the idol from great distances, just as Christian folk go from afar on a pilgrimage to St. Peter's. . . .[13]

In China, says Odoric, the Great Khan's palace is four miles round, its gardens stocked with game, adorned with refreshing lakes, set with pavilions that have columns of gold fringed with pearls, "and in every corner thereof is a dragon represented in act of striking most fiercely." He continues:

In the hall of the palace also are many peacocks of pure gold . . . which flap their wings and make as if they would dance. And this must be by diabolical art or by some engine underground.[14]

Herodotus was not more ingenuous than this.

Theological literature followed the traditions of the Fathers. When it did not condemn the

arts as dangerous vanities, it would ignore the
arts or use them for purposes of religious instruc-
tion. In the latter case, the arts were generally
looked upon as a science of symbolism. Theo-
logians would read deep meanings into the dis-
positions of church buildings and the ornaments
therein, and would give full rein to the mediaeval
passion for allegory. Hence a Crucifix, far from
being admired for its own sake as a work of art,
was only the occasion of a fervent sermon on the
Passion of Christ. Pictorial descriptions thus
became the point of departure for moralizing.
Whole Old and New Testament histories were
inspired by a few serial frescoes.[15] Even the
philosophic Schoolman did not include aesthetic
discussions in his curriculum. Passages in the
Summa Theologica of St. Thomas Aquinas have
definitions of Beauty and Goodness, and indeed
of "beautiful things." [16] They were no doubt
borrowed from Aristotle, and seem, if anything,
to treat of art as an intellectual, not as an aes-
thetic, activity of the soul. There is a long dis-
tance between this anaemic Aristotelianism and
the full-blooded aesthetics which was to mark
the Renaissance. Probably the nearest approach
to a doctrine of Beauty in the Middle Ages was

the Neo-Platonic treatise of Dionysius the Areo-
pagite, *On Divine Names*, which achieved so ex-
traordinary a popularity in all the learned circles
of Europe. It represented Beauty as one of the
Divine Names, but *ipso facto* that Beauty had no
more to do with aesthetic Beauty than Plato's
ideal of moral Beauty aforetime.

A survey of mediaeval literary records dis-
covers not one effective mention of Fine Art as
Fine Art. With all the glamor with which medi-
aeval architecture, sculpture and painting has
been invested in modern times, there is never an
adequate contemporary appreciation. The moral
resistance, the gold-and-glitter, and the primitive
realism are met in many places, but the mediaeval
mind was ignorant of the more sophisticated aes-
thetic values. Evidently the temperament of
archaic Greece was alive again. The Middle
Ages must be recognized as an era when formal
beauty in Fine Art, a self-conscious thought or
act, did not exist.

Then came the Renaissance. Rightly under-
stood the Renaissance was no more and no less
than the rebirth of the old Hellenistic type of
aesthetics. To represent the Renaissance as the
rebirth of ancient *forms* only is to misinterpret its

true place in the cycle of history. That the Renaissance assumed and recovered the ancient forms was its accident and not its essence. The spirit that could admire those forms had need to exist first. In many senses, the Middle Ages were as ancient in sympathy as the Renaissance. For antiquity long after the fall of Rome remained in the memory of men as a Golden Age, which mediaeval idealism constantly aspired to recreate. And it was this tradition of antiquity handed down through the centuries of the Christian era, which demanded that, when the principles of Fine Art were restored, the art forms should be ancient also.

The true difference between the Middle Ages and the Renaissance was therefore aesthetic in character. Mediaeval scholars had possessed and studied the ancient Classics, not for their beauty, but for their moral lessons. It cannot be forgotten how the old monks would try to write the Latin of Cicero and all but made Virgil a saint. But then Cicero to them was a citadel of holy conduct, and Virgil, it was firmly believed, had prophesied the coming of Christ. The discovery which the Renaissance made was not the discovery of the great treasures of antiquity long

buried in the darkness of the Middle Ages, but the discovery that these treasures were *beautiful*. Cicero and Virgil were found to be artists of rare appeal, to be loved not only for the things they said, but also for the way they said them.

In this manner did aesthetic self-consciousness return. Its history thereafter is familiar enough and does not need to be retold. Pictures began again to be painted, and statues to be carved, less for what they represented and taught, and more for what they looked like. Dilettantism was restored, and its peculiar attitude to the antique flourished again. The individual artist was promoted to high station and justified the name of Humanist, which he was to bear. And then again came Graeco-Romanism. The sobriety and "Classicism" of the early Renaissance masters gave place to the Romantic doctrines of irrational fancy, untrammeled genius and creative hysteria. The scholar and amateur contrived more and more to assume the dictatorship of taste, and to cultivate Fine Art as the insignia of intellectual aristocracy. Art was emptied of its contents, exempted from the service of religion and morals, and was resolved at the last into the decorative for its own sake. Archaistic revivals

and a general seizure of pessimism completed the story. Modern aesthetics believes now all the tenets of Lucian and Plotinus — and knows it not.

The study of ancient aesthetics, which in this Essay began with a few innocuous quotations from Homer, has therefore revealed a suggestive philosophy. Both ancient and modern, both the Pagan and Christian eras, seem to have had a parallel aesthetic history. In both eras two aesthetic states of mind have existed successively. The first state of mind was that which, say, deified the sun and prayed to it; the second poetised self-consciously and said: "How beautiful!" It was the first state which caused the Parthenon to be built; it is the second state, which now ponders its ruins, argues about its reconstruction and sees passionate and romantic visions. The like of Homer, the Lyric poets, Herodotus, Thucydides belong to the first state; the like of Strabo, Plutarch, Lucian, Philostratus, Athenaeus, Plotinus to the second; Aristotle, and to a less extent Plato, are the links between the two. That is the long and the short of the aesthetics of antiquity, and may be also, in some subtle way, the analogue of the whole procession of ancient and modern culture.

Beauty in Fine Art is no eternal birthright of man for his joy and elevation. Beauty is born, lives for a time and dies a pre-ordained death. Beauty is independent of the various material forms of architecture, sculpture and painting, which may be created for other ends than Beauty, but which Beauty may later take temporarily as its vehicle. All these things, the arts, have had an existence apart from the Beauty, which presumes now to justify and sanctify them. Ancient art, like modern art, had an historical destiny, and its meaning and moral are missed, if the revolutions of its values are not appreciated.[17]

NOTES

CHAPTER I

1. *Il.*, xviii, 288.
2. *Od.*, vii, 86; cf. *Il.*, xviii, 368; *Od.*, iv, 71.
3. *Il.*, xvi, 130; *Od.*, xi, 15; cf. *Od.*, xi, 609.
4. *Il.*, xviii, 478 ff.
5. *H. Hom., Herm.*, 384.
6. *H. Hom., Pyth. Apoll.*, 287.
7. *H. Hom., Aphrod.*, 84; cf. *Il.*, xiv, 178; Hes., *Theog.*, 570; Hes., *W. D.*, 69.
8. Hes., *Shield.*, 139, etc.
9. Sappho, *Frag.*, 66.
10. Pind., *Olymp.*, vi, 1; ii, 130.
11. Hdt., i, 183.
12. Thuc., ii, 40.
13. *Ib.*, ii, 38.
14. *Ib.*, ii, 41.
15. *Ib.*, ii, 15.
16. *Ib.*, ii, 13.
17. Eur., *Ion*, 184.
18. Eur., *Hec.*, 560.
19. Eur., *Ion*, 185; cf. *Orest.*, 1371.
20. Eur., *Hec.*, 807; cf. *Alc.*, 348.
21. Xen., *Mem.*, I, iv, 3.
22. *Ib.*, III, x, 1.
23. *Ib.*, III, x, 6.
24. Plato, e. g., *Soph.*, 239.

25. Aristot., *Poet.*, xxv (1460 b.).
26. Aristot., *Pol.*, viii, 5 (1340 a).
27. Paus., vi, 11; cf. Plut., *De Sera Num. Vind.*, 8. Lucian, *Philopseud.*, 19; Ath., xiii, 84; xv, 12; Ael., *Var. Hist.*, ii, 3; ii, 44; *Greek Anthology*, ix, 584 ff.
28. Pliny, *N. H.*, xxxv, 65.
29. Strabo, IX, i, 16.
30. Paus., v, 21.

CHAPTER II

1. Plut., *Lycurg.*, 4.
2. Plut., *Cleom.*, 2.
3. Plut., *Agis.*, 10.
4. Plut., *Lycurg.*, 13.
5. Plut., *Solon*, 29.
6. Diog. Laert., i, 59.
7. Plut., *Aristeid.*, 25; cf. Plato, *Gorg.*, 518–519.
8. Xen., *Mem.*, IV, vi, 9; cf. III, viii, 5–6.
9. Plato, *Rep.*, iii, 387.
10. *Ib.*, iii, 401; cf. ii, 377–378.
11. *Ib.*, x, 603.
12. *Ib.*, x, 605.
13. *Ib.*, v, 476.
14. Aristot., *Poet.*, xv (1454 a).
15. *Ib.*, xxv (1461 b).
16. *Ib.*, xv (1454 b); cf. Lucian, *Pro Imag.*, 6; and Lucian, *De Hist. Conscrib.*, 13.
17. Aristot., *Pol.*, viii, 5 (1340 a); cf. *Rhet.*, i, 2 (1371 b).
18. Diog. Laert., viii, 21.
19. *Ib.*, ix, 1.
20. *Ib.*, ix, 18.
21. *Ib.*, vi, 20, etc.

22. Philostr., *Vit. Apoll.*, i, 30; iv, 78; cf. Apoll. Tyan., *Epist.*, 32; Philostr., *Vit. Apoll.*, v, 22.
23. *Od.*, xii, 188.
24. Aristoph., *Frogs*, 1008; cf. 1052; 1500; etc.

CHAPTER III

1. Plato, e. g., *Phaedrus*, 266.
2. Plato, *Apol.*, 22; N. B., this is spoken in reproach of poets.
3. Aristoph., *Wasps*, 1212.
4. Plato, *Laws*, vi, 761; cf. *Rep.*, ii, 373.
5. Plato, *Critias*, 115–116.
6. And this should be remembered when interpreting the favourite sentence of Plato's: "The affairs of the Muses ought somehow to conclude in the love of the beautiful." *Rep.*, iii, 403.
7. Aristot., e. g., *Eth.*, x, 4 (1174 a).
8. Aristot., *Pol.*, viii, 3 (1338 a); viii, 5 (1339 a); etc.
9. Aristot., *Poet.*, iv (1448 b).
10. *Ib.*, xxv (1460 b).
11. *Ib.*, vi (1450 b).
12. Aristot., *Rhet.*, iii, 12 (1414 a).
13. Menand., *Frag.*, 285; cf. *Frags.*, 24; 503.
14. Aristot., *Eth.*, x, 9 (1181 a).
15. Aristot., *Pol.*, viii, 3 (1338 a–b).
16. Aristot. (?), *De Mir. Auscult.*, 81; 100.
17. Theoph., *Char.*, 5.
18. *Ib.*, 24.
19. Arrian, *Anab.*, i, 11–12.
20. Strabo, XIII, i, 26.
21. *Ib.*, XVI, i, 5.
22. Polyb., iv, 40.
23. *Ib.*, x, 27.

24. Vitruvius gives a whole bibliography of this literature in the Preface to Bk. vii.
25. Philostr., *Sophist.*, i, 11 (495); ii, 23 (605); ii, 26 (613).
26. K. Jex Blake & E. Sellers, *Elder Pliny's Chapters on Art. Introduction.*
27. Ath., xii, 57.
28. Cic., *De Nat. Deor.*, iii, 34.
29. Ath., v, 21.
30. Plut., *Arat.*, 13.
31. Ath., v, 53.
32. *Ib.*, vi, 15.
33. Strabo, V, iii, 9.
34. *Ib.*, XVII, i, 28.
35. *Ib.*, X, iii, 9–10; cf. Ath., xii, 79.
36. Plut., *Public.*, 15.
37. Plut., *Peric.*, 13.
38. Plut., *De Pyth. Oracul.*; cf. Lucian, *Philopseud.*, 4; Lucian, *Mort. Dial.*, 18; 20; Lucian, *Charon*; Emp. Julian, *Epist.*, 19.
39. Paus., vii, 23; ix, 30.
40. *Ib.*, v, 23.
41. *Ib.*, vii, 5.
42. *Ib.*, i, 36.
43. *Ib.*, iii, 19.
44. *Ib.*, viii, 40.
45. *Ib.*, i, 24.
46. *Ib.*, ii, 4.
47. *Ib.*, ix, 36.
48. Ath., xi, 24.
49. *Ib.*, v, 22; v, 38; v, 41.
50. *Ib.*, vii, 1.
51. Philostr. *Sophist.*, i, 25 (532–533) *The Greek Anthology* contains epigrams by Polenus.
52. Lucian, *De Dom.*, 4–8.
53. Philostr., *Vit. Apoll.*, vi, 19; cf. ii, 22.
54. *Ib.*, vi, 11.

NOTES

55. *Ib.*, ii, 20. Philostratus also has plenty of gold-and-glitter, *ib.*, i, 25; ii, 20; ii, 24; v, 5; etc. Philostratus was also author of the *Imagines*, an account of pictures in a gallery. It is an effusive work, "archaic" in its appreciations, but notes what would now be called perspective and chiaroscuro. There is a second Imagines by a Philostratus, grandson of the preceding. Cf. Callistratus. *Descriptions.*

56. Plotin., *Ennead.*, I., iii, 1–2; I, vi, 1.

CHAPTER IV

1. Plut., *Fab. Max.*, 22; Strabo, VI, iii, 1.
2. Polyb., ix, 10.
3. Plut., *Marcell.*, 21.
4. Plut., *Cato Maj.*, 4; etc.
5. Polyb., xxxix, 13–14; cf. Strabo VIII, vi, 23. But later Mummius appears to have altered his ways — Polyb., xxxix, 17.
6. Plut., *Sull.*, 12, etc.
7. Sallust, *Iug.*, lxxxv, 32–33.
8. Plut., *Maxius*, 2.
9. Sallust, *Cat.*, xi, 6.
10. Cic., *Pro Rosc.*, 46.
11. Cic., *Pro Leg. Man.*, 14.
12. Cic., *De Fin.*, ii, 34.
13. *Ib.*, ii, 33.
14. Cic., *In Verr.*, v, 32; etc.
15. Varro, *De Re Rust.*, e. g., III. iii. 6; cf. Columella; I, 1; x, 27.
16. Varro, *De Re Rust.*, II, Pr., 2.
17. *Ib.*, III, ii, 4–5.
18. *Ib.*, III, iii, 9.
19. Hor., *Epist.*, I, vi, 17; cf. *Sat.*, II, iii, 22.

20. Livy, vii, 2.
21. *Ib.*, xxv, 40.
22. *Ib.*, xxiv, 34.
23. *Ib.*, ix, 40.
24. *Ib.*, e. g., x, 46; xlv, 40.
25. *Ib.*, xlv, 27–28.
26. Tac., *Ann.*, xiv, 20; cf. iii, 53.
27. Sen., *De Benef.*, vii, 9.
28. Sen., *Epist.*, 86.
29. *Ib.*, 90.
30. *Ib.*, 88.
31. Fronto, *Ad. M. Caes.*, iv, 4.
32. M. Aurel. Ant., *Medit.*, i, 11.
33. *Ib.*, i, 17.
34. Juv., i, 75.
35. *Ib.*, i, 94.
36. *Ib.*, v, 40.
37. *Ib.*, xi, 100.
38. *Ib.*, iii, 224.

CHAPTER V

1. Plut., *Paul. Aem.*, 6.
2. Plut., *Sull.*, 26.
3. Pliny, *N. H.*, xxxvi, 189.
4. Jul. Caes., *De Civ. Bell.*, iii, 33; iii, 96.
5. Dio, xlii, 14.
6. Strabo, VIII, vi, 23.
7. *Ib.*, xiii, i, 27.
8. Pliny, *N. H.*, vii, 126.
9. Suet., *Jul.*, 47.
10. *Ib.*, 44.
11. *Ib.*, 56; cf. Cic. *Ad Fam.*, ix, 16.
12. Cic., *Ad Quint. Frat.*, iii, 1.

13. Cic., *In Verr.*, ii, 51.
14. Cic., *Acad.*, ii, 20.
15. Cic., *Ad Att.*, i, 8.
16. *Ib.*, i, 9.
17. Cic., *De Orat.*, iii, 46.
18. Cic., *Brut.*, 18.
19. Cic., *In Verr.*, v, 1.
20. *Ib.*, ii, 21.
21. Vitruv., i, 1.
22. *Ib.*, i, 1; i, 2.
23. *Ib.*, vi, 8; cf. Quint., III, vii, 27.
24. Suet., *Aug.*, 72.
25. *Ib.*, 70.
26. Tac., *Ann.*, iv, 37.
27. Suet., *Aug.*, 28.
28. Suet., *Calig.*, 37; 52; 53; 57.
29. Pliny, *N. H.*, xxxv, 51.
30. Plut., *Public.*, 15.
31. Martial, viii, 6; viii, 34.
32. Statius, *On the Pleasaunce of Vopiscus at Tivoli.*
 On the Baths of Claudius Etruscus.
 On the Country Villas of Pollius and Polla.
 On the Dedication of Temple by Pollius to Hercules.
 On Vindex and his Treasures.
 Note in the poems the constant references to the beauty of marbles.
33. Quint., XII, x, 3–9.
34. Tac., *Hist.*, ii, 3.
35. *Ib.*, iv, 53.
36. Tac., *Ann.*, xv, 41.
37. *Ib.*, xv, 43.
38. Pliny, *N. H.*, xxxvi, 1.
39. *Ib.*, xxxvii, 1.

40. *Ib.*, xxxv, 67.
41. *Ib.*, xxxvi, 27.
42. *Ib.*, xxxvi, 27.
43. *Ib.*, xxxiv, 11.
44. Pliny, *Epist.*, iii, 1; cf. iii, 7.
45. *Ib.*, ii, 17; v, 6; vi, 31; ix, 7.
46. *Ib.*, viii, 18.
47. *Ib.*, viii, 8.
48. *Ib.*, viii, 20.
49. *Ib.*, iii, 6.
50. *Script. Hist. Aug. (Hadr.)* 1.
51. *Ib.*, 14.
52. *Ib.*, 19.
53. *Ib.*, 16.
54. *Ib.*, 26.

CHAPTER VI

1. Pliny, *N. H.*, xxxiv, 55.
2. Xen., *Oecon.*, viii, 19–20.
3. Aristot., *Eth.*, vi, 7 (1141 a).
4. Aristot., *Metaph.*, iii (1078 a); cf. Plato, *Phileb.*, 51.
5. Vitruv., vii, *Pr.* For "refinements" in sculpture cf. Plato, *Soph.*, 235–236; Tzetzes, *Chil.*, viii, 340.
6. Plato, *Laws*, ii, 657.
7. *Ib.*, iii, 700.
8. *Ib.*, vi, 769.
9. Aristot., *Poet.*, xxiv (1460 a).
10. Thuc., ii, 13.
11. Pliny, *N. H.*, xxxv, 145.
12. *Ib.*, xxxv, 92.
13. *Il.*, v, 59.
14. Xen., *Oecon.*, iv, 3; vi, 13–16.
15. Pliny, *N. H.*, xxxv, 71.

16. *Ib.*, xxxv, 62.
17. *Ib.*, xxxv, 85.
18. *Ib.*, xxxv, 86–87.
19. *Ib.*, xxxiv, 63; vii, 125.
20. *Ib.*, xxxv, 77.
21. *Ib.*, xxxv, 19–21.
22. *Ib.*, xxxv, 62.
23. *Ib.*, xxxv, 71; Aelian, *Var. Hist.*, ix, 11.
24. Vitruv., ii, *Pr.*
25. Aristot., *Pol.*, ii, 8 (1267 b).
26. Aelian, *Var. Hist.*, iii, 31.
27. Pliny, *N. H.*, xxxv, 105.
28. Aelian, *Var. Hist.*, xii, 41.
29. Pliny, *N. H.*, xxxiv, 81.
30. *Ib.*, xxxvi, 40.
31. *Ib.*, xxxv, 120.
32. Ovid, *Ex Pont.*, I, v, 31.
33. Aristot., *Poet.*, xvii (1455 b), etc.
34. *Ib.*, ii (1448 a).
35. Plotin., *Ennead.*, III, ii, 11.
36. Theoph., *Char.*, *Pr.*
37. Diog. Laert., v, 59. Diogenes Laertius also mentions Zeno the Stoic as a writer on Human Nature, vii, 4.
38. Cic., *De Nat. Deor.*, i, 30.
39. Pliny, *N. H.*, xxxv, 112.
40. *Ib.*, xxxv, 116–117.
41. Lucian, *De Calumn.*, 5.
42. Pliny, *N. H.*, xxxiv, 77–78.
43. *Ib.*, xxxv, 78.
44. Many of these exist to-day. Cf. Polyb., xxxi, 15.
45. Philostr., *Vit. Apoll.*, ii, 24; iii, 58; iv, 28; etc. Plotin., *Ennead.*, III, vi, 19; IV, iii, 11; etc.
46. Philostr., Jun., *Imag. Pr.*
47. Longin., 5.

48. Lucian, *Zeux. seu Antil.*
49. Cic., *De Orat.*, ii, 45.
50. Quint., II, iv, 6.
51. Martial, i, 52; i, 53; etc.
52. Lucian, *Zeux. seu Antil.*, 3.
53. Ath., xi, 28.
54. Pliny, *N. H.*, xxxiv, 61.
55. *Ib.*, xxxiv, 65.
56. *Ib.*, xxxv, 80.
57. *Ib.*, xxxv, 92.
58. Ath., xii, 64.
59. Cic., *De Orat.*, iii, 7.
60. Pliny, *N. H.*, xxxv, 75.
61. Longin., 2.
62. *Ib.*, 33.
63. Lucian, *De Hist. Conscrib.*, 8.
64. Cic., *De Orat.*, ii, 57; cf. i, 32 — (Sic esse non elo-
 quentiam ex artificio; sed artificium ex eloquentia
 natum.)
65. Pliny, *N. H.*, xxxv, 106.
66. Quint., I, *Pr.* 24; I, *Pr.*, 26.
67. Philostr., *Sophist.*, ii, 18 (599).
68. Lucian, *Imag.; Pro Imag.*
69. Lucian, *De Dom.*, ii.
70. Longin., e.g. 8 (τὸ σφοδρὸν καὶ ἐνθουσιαστικὸν πάθος).
71. Statius, *Silv.*, II, ii, 36.
72. Porphyr., *De Abstin.*
73. Cic., *Orat. ad Brut.*, 50.
74. Petron., *Satyr.*, 88.
75. Pliny, *N. H.*, xxxv, 50.

CHAPTER VII

1. E. g., Euseb., *Eccles. Hist.*, x, 4; St. Greg. Nyss., *Epist.*, 16; St. Basil, *Hexaem.*, i, 7; iii, 10; etc. Procop., *Aedif. Justinian*, i. Consult also W. R. Lethaby & H. Swainson, *Santa Sophia*, which quotes other Greek writers.

2. *Matt.*, xxiv, 2; *Mark*, xiii, 2; *Luke*, xxi, 6.

3. St. Augustine, *Confess.*, iv, 13–14; cf. x, 33–35.

4. St. Gregory, *Epist.*, xi, 13; cf. ix, 105.

5. Decree of the Second Council of Nicaea.

6. St. Francis, *Colloq.*, 3.

7. St. Francis, *Mirror of Perfection*, 5, etc.

8. St. Francis, *Testament.*

9. *The Ruin*

10. Consult for further information and examples: —

 Henry III's orders to his craftsmen, in the *Liberate Rolls*, A Selection published in Hudson Turner, *Domestic Architecture of England.*

 Rites of Durham, published by the Surtees Society.

 Quellenschriften Texts, especially *Quellenbuch zur Kunstgeschichte des Abendländischen Mittelalters*, pp. 121, 134, 218, 240, 252, 268, compiled by Julius von Schlosser.

 Recueil des Textes relatifs à l'Histoire de l'Architecture en France au Moyen Âge, compiled by Victor Mortet.

11. Theophilus, *De Diversis Artibus:* Villars de Honnecourt, *Notebooks.* Consult also M. P. Merrifield, *Original Treatises from the Twelfth to the Eighteenth Centuries in the Arts of Painting.*

12. Bohn's Antiquarian Series, *Travellers in Palestine.*

13. Odoric, 18.

14. *Ib.*, 37.

15. Vide Note 10 of this Chapter. Also cf. Durandus of Mende, *Rationale Divinorum Officiorum*.

16. St. Thomas Aquinas, *Summ. Theol.*, I, v, iv, 1; I, xxxix, viii, I–II, xxvii, i, 3.

17. Finally in his Conclusion, the present writer begs to excuse himself from the charge of being influenced by Spengler's *Decline of the West*. This essay was complete, though not in its present form, some time before Spengler came into the writer's hands. The reader may judge for himself if the essay in any way anticipates the principal argument of Spengler's great work.

CHRONOLOGICAL TABLE

CHRONOLOGICAL TABLE

(Dates, approximately known, in *italics*)

	GREEK AUTHORS	LATIN AUTHORS	CONTEMPORARY HISTORY
			Trojan War (*1100*) "Return of the Heracleidae"
800 B.C.	Homer (fl. *850*)		Legislation of Lycurgus in Sparta (*850–800*) Founding of Rome (*753*)
700 B.C.	Hesiod (fl. *735*)		
600 B.C.	The Lyric Poets (fl. *600–450*)		Legislation of Solon in Athens (*594*)
500 B.C.	Aeschylus (*525–456*)		Pythagoras (fl. *525*)

Sophocles (495–406)	First Persian War (490)
Euripides (480–406)	Second Persian War (480–479)
Herodotus (484–?)	
Thucydides (471–401)	Pericles (fl. 460–431)
Aristophanes (444–380)	
Xenophon (440–355)	Building of the Parthenon (443–438)
	Peloponnesian War (431–404)
400 B.C.	Death of Socrates (399)
Plato (419–347)	
Aristotle (384–322)	
Theophrastus (d. 287)	
	Conquests of Alexander the Great (336–323)
Menander (342–291)	

	GREEK AUTHORS	LATIN AUTHORS	CONTEMPORARY HISTORY
300 B.C.	Theocritus (fl. 285)		Ptolemaic Dynasty in Egypt (323 ff.)
			First Punic War (264–241)
			Second Punic War (218–201)
			Marcellus captures Syracuse (212)
	(fl. 200)		Cato the Elder (234–149)
200 B.C.	Polybius (204–122)		Macedonia becomes a Roman Province (146)
			Destruction of Corinth (146)
100 B.C.			Pergamon becomes a Roman Province (133)

Date	Writers	Events
100 B.C.	Varro (116–28)	Death of Marius (86)
	Cicero (106–43)	Death of Sulla (78)
	Julius Caesar (100–44)	Pompey and Crassus Consuls (70)
	Sallust (86–34 B.C.)	Assassination of Julius Caesar (44)
	Vitruvius (fl. 45 B.C.)	Augustus Emperor (31 B.C.–14 A.D.)
	Livy (59 B.C.–17 A.D.)	
	Virgil (70–19 B.C.)	
	Horace (65–8 B.C.)	
B.C. 0 A.D.	Ovid (43 B.C.–18 A.D.)	MINISTRY OF JESUS CHRIST
	Seneca (5 B.C.–65 A.D.)	
	Strabo (64 B.C.–24 A.D.)	Tiberius Emperor (14–37)
		Caligula Emperor (37–41)

GREEK AUTHORS	LATIN AUTHORS	CONTEMPORARY HISTORY
	Petronius (fl. *50–68*)	Nero Emperor (*54–68*)
	Martial (*40–104*)	
	Pliny the Elder (*23–79*)	Vespasian Emperor (*69–79*)
	Quintilian (*40–118*)	
	Statius (*61–120*)	
Plutarch (fl. *80–100*)	Tacitus (*60–110*)	Domitian Emperor (*81–96*)
	Pliny the Younger (*61–105*)	
	Juvenal (fl. *80–100*)	Trajan Emperor (*98–117*)
	Suetonius (fl. *100*)	
Pausanias (fl. *160–180*)		Hadrian Emperor (*117–138*)
Lucian (fl. *160–180*)		Marcus Aurelius Emperor (*161–180*)

100 A.D.

(138)

200 A.D.	Philostratus (fl. 200–250) Athenaeus (fl. 230) Longinus (fl. 250) Plotinus (203–262) Porphyry (fl. 250)	Septimius Severus Emperor (193–211) Caracalla Emperor (211–217) First Invasion of the Goths (250)
300 A.D.		Diocletian Emperor (284–305) Constantine Emperor (306–337) Founding of Constantinople (330)
400 A.D.	St. Augustine (354–430)	